Using Calligraphy

OTHER COLLIER BOOKS BY
Margaret Shepherd

Learning Calligraphy
A Book of Lettering, Design, and History

Borders for Calligraphy
How to Design a Decorated Page

Capitals for Calligraphy
A Sourcebook of Decorative Letters

⁓

Calligraphy Made Easy

Margaret Shepherd's Calligraphy Calendar

Using Calligraphy

A Workbook of Alphabets, Projects, and Techniques

MARGARET SHEPHERD

Collier Books
A Division of Macmillan Publishing Co., Inc.
New York

Collier Macmillan Publishers
London

Macmillan Publishing Co, Inc.
866 Third Avenue, New York, N.Y. 10022
Collier Macmillan Canada, Inc.

LIBRARY OF CONGRESS CATALOGING IN PUBLICATION DATA

Shepherd, Margaret
 Using calligraphy.

 1. Calligraphy — Technique. I. Title.
NK3600.S54 745.6'1 79 — 18754

ISBN 0 - 02 - 081970 - 6

First printing 1979
Sixth printing 1982

Printed in the United States of America

TABLE OF CONTENTS

USING THIS BOOK

The pleasures of calligraphy are accessible to anyone with pen, ink, paper, a tolerance for practice, and an appetite for seeing. With a little experience, calligraphers begin to see beautiful lettering everywhere—from name tags to honorary degrees—and realize that calligraphy is not only a rich traditional art but also a contemporary skill with dozens of everyday uses. Everyone can participate on some level.

USING CALLIGRAPHY concentrates on the practical side of the calligrapher's art. Workmanship is covered first in a thorough discussion of materials, geared to different levels of expertise. Next, a workbook section offers review of the five basic scripts and easy experimental exercises for nearly 50 alphabet variations. After that, seven different simple projects are explained in detailed chapters on the calligrapher's everyday work. Finally, the freelancer can learn valuable business skills to cope with the challenges of artistic self-employment.

You can use this book by itself or as a supplement to your own lessons. If you feel the need for a more detailed course about basic technique and history, LEARNING CALLIGRAPHY by Margaret Shepherd will provide balance. Either way, USING CALLIGRAPHY offers a wealth of helpful suggestions and know-how drawn from the author's long experience as a scribe.

ACKNOWLEDGEMENTS

I wish to thank those who contributed illustrations to USING CALLIGRAPHY. The logos on page 97 were kindly lent by their calligraphers: Mort Siegel, Susan Barrett Price, Kathie McCrory, Marc Drogin, Ann Bottelli, Garrett A. Boge, and Ray F. DaBoll. Those on page 101 are used here by the courtesy of the companies they symbolize: Mutual Bank, M.I.T. Press, Mapco, Prime Computer, G F Office Furniture Systems, J. J. Case Co., Sack Theatres, Zildjian, and Mu-Tron. The designer's name is given if known. Two works by Arthur Baker are included here, with gratitude for his cooperation. The photographs on page 95 were taken by Peter Williams of Museum Services; those on page 81 are from E.P. Jones and Stock Photo. The historical examples on pages 25 and 81 are used with the kind permission of Dover Publications and the Pierpont Morgan Library, respectively. Alice Wang Chen graciously provided the Chinese calligraphy on page 86. All other illustrations are from the author's portfolio.

I am further indebted to Anna Dunwell, whose initial encouragement helped to melt a writer's block of glacial proportions, to Jane Etzel, who kindly read Chapters III and IV, to Wendy Mela, who for a year never failed to inquire about this book's health, and to Rusty Gutwillig at Macmillan, whose expertise helped this manuscript become A MANUSCRIPT.

Finally, I owe thanks of a special kind to my main sources of strength, pictured here by their own hand:

My college friend and longtime fellow calligraphy student Lydia Murphy Savage, whose facility with pen and penguin has inspired me for years,

Those of my fellow scribes whose talents I admire and whose designs I always wish I'd thought of,

Grandmother extraordinaire Miriam Friend, who lent many a hand and borrowed many a toddler,

My husband David Friend, whose optimism is relentless, whose stoicism is boundless, and whose stamina for literary criticism never ends.

Margaret Shepherd
1 September 1979
Boston

For my mother

Eleanor Murray Shepherd

who has always been
my favorite writer

I

Pens, Pigments, Paper, and Proficiency

La carrière ouverte aux talents. —*Napoleon*
The tools to him that can handle them.

When you begin, the watchword is PRACTICE. Stay with a beginner's pen until the letter forms look familiar and the pen feels natural in your hand. Enjoy the special qualities of the pen. If you rush ahead to try complicated designs on expensive paper with an advanced pen you won't get the free, relaxed, repetitive practice you need at this stage. Carry a chisel-tip felt pen with you for a week, and use it everywhere you normally write with a felt pen. You'll become sensitive to your calligraphy pen, to its weaknesses and strengths, its limits and potential.

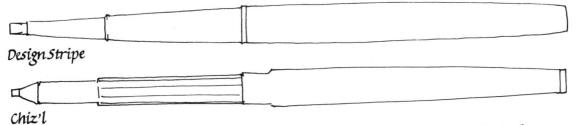

Design Stripe

Chiz'l

Two chisel-tip felt pens are shown here; one brand has a slightly wider tip than the other. They are available in art, craft, and stationery stores, or by mail from the manufacturer.

Your calligraphy felt pen, because of its wide tip, may seem to use up its ink supply faster than a thin-tip felt pen. Guard against this by capping it securely whenever you are not writing with it. If you live in a dry climate, a small moistened ball of cotton in the cap can prolong the pen's liquid supply. If the tip gets ragged or mushy, trim it back into shape with a very sharp razor blade. Shave the fibers off the flat side of the tip. Avoid altering the width of the point.

Almost any kind of inexpensive typing or copy machine paper will do at this point. Use it up and throw it away — 500 sheets in a month means you're making real progress. If you think you're improving and just can't bear to throw away a particularly good practice sheet, save it. Circle the best letter and file it away for a month. You'll enjoy it later as a kind of baby picture of your developing abilities as a calligrapher.

Design CPM

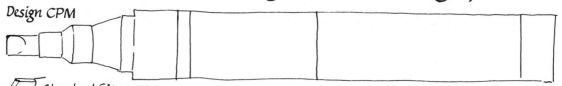

Standard felt pen tip — not for calligraphy

If you want to lay the groundwork for a thorough understanding of the letters — if you think you might have the talent, interest, and patience to study calligraphy in great depth — get acquainted with a wide pen. Work large, so that your eyes can participate in every nuance of what your hand is doing. Make long, smooth arm motions. The effect of these oversize letters is an astonishing clarification of detail, like aiming a telescope at the night sky; details only guessed at are now plainly visible. The wide pen is worth the extra effort.

You need little else at this point but instruction. Some books can help you teach yourself, if you can discipline yourself to practice. If you want lessons, seek out programs at your local arts and crafts society, YMCA or YWCA, adult education center, or museum school. The lessons in Learning Calligraphy or in the first part of this book's alphabet section, plus a friend with a little experience to answer your first questions, can teach you all you need to make a good start.

Now you can begin to appreciate the advantages of a more refined tool — the calligraphy fountain pen. It gives you sharper contrast between thick and thin, better ink coverage, and a greater choice of nib sizes. It travels well in your pocket (except onto an airplane, where the changes in air pressure will make it leak). It can last many years, growing to be an old reliable friend.

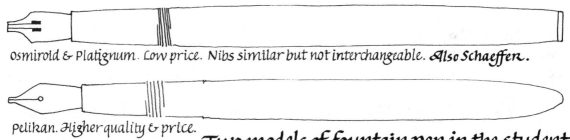

Osmiroid & Platignum. Low price. Nibs similar but not interchangeable. *Also Schaeffer.*

Pelikan. Higher quality & price.

Two models of fountain pen in the student price range are shown above. The less expensive brands offer nib selection with wide nibs for large-letter practice of the lessons in this book; the higher-price pens are limited to narrower handwriting nibs of smoother, more durable quality. Beyond the brands suggested here you may find that a fancier fountain pen makes you feel more special about your writing but does not make any real visible improvement.

Sharp pointed pen. Clip off tip... ...to desired width. Hone on carborundum. Fill and write.

You can make a quite serviceable calligraphy

pen by cutting the tip off a conventional fountain or cartridge pen and then honing it down smooth on a carborundum stone. This is a particularly good solution for group instruction on a limited budget; you have to blunt only one clipper and buy only one carborundum stone to make a whole batch of pens.

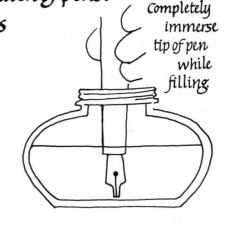
Completely immerse tip of pen while filling

With fountain pens you should use a black ink specially formulated for calligraphy. The crucial thing to remember is this: DO NOT use India ink in a fountain pen. It will clog up, solidify, form a crust, and ruin your pen.

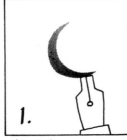
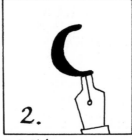
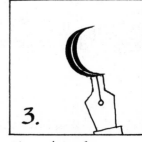

Correct stroke Thin ink Ink blobs Striped Stroke

You may need a little time to accustom yourself to the pen. At first, pull all strokes down or to the right, to insure steady lines and even ink coverage. If you have any difficulty, try to analyze it by studying the pen stroke. Some common problems are shown above: 1. Thin, watery, uneven ink coverage. The pen could be empty of ink or blocked by dried-up ink in the nib. 2. Blobs of ink. Make sure you have wiped the pen carefully after filling. Some pens, when they get near empty, release their last bit of ink in a panic. 3. White gap in the

middle of the stroke. Too much or too little pressure.

If, after reasonable effort and perhaps an outside expert opinion, you still cannot get the pen to write smoothly, you may have a lemon. Take it back where you got it. Don't let a balky pen spoil your practice.

The 20th century student can select from several specially formulated mass-produced calligraphy papers. Strathmore Document Paper, in white only, offers a smooth, hard surface on one side. Strathmore Manuscript Paper is a translucent cream color, with a somewhat softer, rougher surface on both sides. Three Candlesticks is a soft white, and like Strathmore Manuscript, features a chain-line design derived from traditional handmade paper, which some calligraphers like to use as approximate guidelines. Bristol Bond in both vellum and plate finish

("cold press" and "hot press") is reliable, inexpensive, and ubi-
quitous, as is the slightly lower-quality <u>Ledger Paper</u> of many
paper companies. <u>Parchment Paper</u> cannot be highly recom-
mended; the surface is slippery and inhospitable to ink.

You can add color to your calligraphy with
a red calligraphy felt pen or fountain pen filled
with red or sepia ink. These simple tools will
enable you to work out designs boldly and practice
gracefully. Favorite designs can be redone with
greater precision using materials from the
next level of expertise.

Many student calligraphers bog down in
their progress at this point; they have a good foundation in the
basic materials and alphabets but don't know what to build onto
that foundation. "Where do I go from here?" "How do I decide
which style to use with which quote?" "What if someone asks
me to letter something for a job?" are common questions. Some
of the answers can be found by branching out. Get to know your
field and the fields that touch it. You may have many years of
practice ahead before you will be satisfied with your technical
skill. While you wait for your hand to catch up, train your
eye and enrich your brain. Take a course in typography, medi-
eval religion, history of art. Yoga or meditation can help ac-
custom you to the concentration needed. Try also photography,
architectural drafting, figure drawing, bookbinding, or print-
making. For a truly fresh perspective, take a beginning course
or a few lessons <u>with a new teacher.</u>

The tools for this level of calligraphy are dominated by the needs and virtues of that strong-willed substance— India Ink. This waterproof, permanent ink can be used only in a pen that is taken apart and cleaned after every use to keep it from drying up solidly and ruining the nib.

Mitchell Roundhand

The backbone of the calligrapher's studio is the Mitchell pen: a wooden or plastic shaft with a brass collar and reservoir nib holder; and a removable steel nib.

Flex pen reservoir

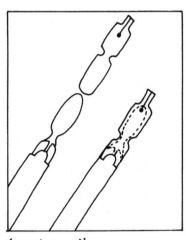

Insert pen nib

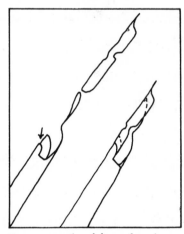

Reservoir should touch nib

To assemble the Mitchell pen, first suck the nib or wash it with soap and water. (Otherwise, the thin film of oil applied by the manufacturer to seal out moisture will prevent the ink from flowing freely.) Flex the reservoir slightly. Slide the nib in between the two layers of the collar.

Now you're ready to put ink into the reservoir in one of two ways.

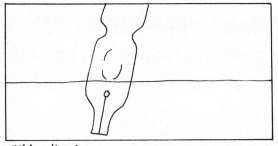
Fill by dipping

Remove excess for sharp writing

To fill the pen by dipping, immerse the assembled pen in India Ink to cover the small hole. Wipe off excess.

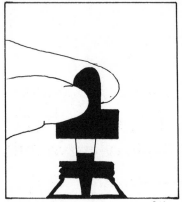
Squeeze dropper stopper to fill

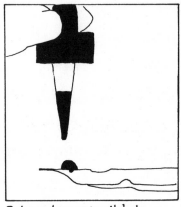
Put one drop onto nib hole

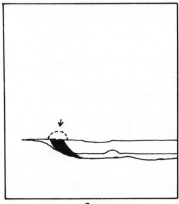
Tap until drop flows into pen

Or fill with a dropper, following the three steps shown above. First, squeeze and release the dropper-stopper of a full, open bottle of India Ink to be sure that you fill the pen with a solid drop of ink rather than a bubble of air. Next, holding the dropper about ⅛" above the horizontal pen, squeeze one drop of ink into the hole. Sometimes, the drop of ink will just bead up and sit there. Before writing, tap or press the pen (reservoir side down) very gently until the ink disappears through the hole. This way of filling the pen is worth learning; it insures that the pen has a clean tip and a predictable amount

of ink every time you fill the pen.

 If the pen is balky at this point, you may have one of a half dozen simple problems. The pen stroke will help your diagnosis.

Correct stroke	1. Striped stroke	2. Ragged edge	3. Ink blobs	4. Rough surface
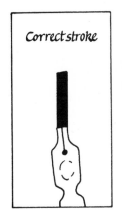	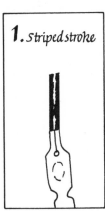	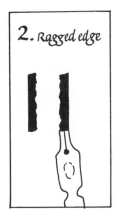	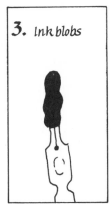	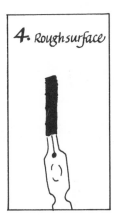

1. Insufficient ink is reaching the ink hole. Possible causes: you need to refill the pen, the reservoir is not touching the back of the nib, or the nib is oily. First blot out with a tissue whatever ink remains in the pen so that you don't blacken your hands. Then take the nib out and reassemble the pen, repeating the needed step. If you still produce this split stroke, you may be pressing too hard.
2. Ragged edges mean you are leaning too hard on one edge of the nib. 3. Too much ink is flooding down over or under the nib rather than flowing evenly from the center hole through the slit. Wipe the dipped nib to remove excess ink before writing, or be sure the ink drop has disappeared into the reservoir. 4. The nib seems to snag and roughen the paper, making the edges of the stroke ragged and furry. Smooth the nib on a carborundum stone.

10 strokes to sharpen 2 strokes to even up Pen point shape

If you put an ink-filled Mitchell pen down for more than a minute, empty it by laying it nib-side down on a folded tissue, paint rag, or damp teabag. Refill it when you need it again. This precaution is essential. Don't let a pen dry up. If the full pen is allowed to dry out, the accumulated crust will push the nib open at the split and ruin it. The nib will never

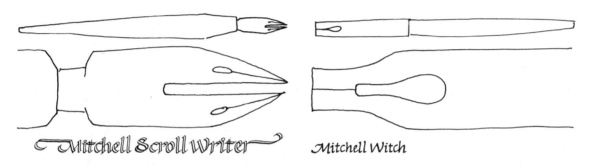

A dead nib

close up tight again, so that both the ink flow and the nib width will be altered.

Mitchell Scroll Writer Mitchell Witch

Two other useful Mitchell pen nibs are shown above in great detail. The double point makes precise, intriguing, minutely accurate outline letters. It can be maddening to work with unless you slow down, refill after every half-dozen letters, and pull every stroke toward you. The "Witch Pen" is a reliable workhorse for large display letters.

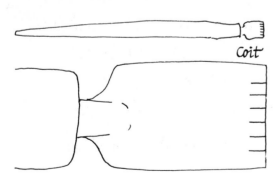

Coit

For oversize letters, try Coit or Box pens and be prepared to refill the pen constantly. Some calligraphers, especially those who come to calligraphy from a commercial art background,

prefer the Speedball brand of pen holders and nibs. The selection of calligraphy nib widths, however, is quite limited.

With all of these pens, use India Ink in a one-ounce bottle with dropper stopper. Some calligraphers believe that India Ink gets better with age and that this improved quality can be imparted to new ink the same way yogurt culture makes yogurt. It is certainly no trouble to replenish the original bottle before it runs out, just in case the superstition has some grounds in truth.

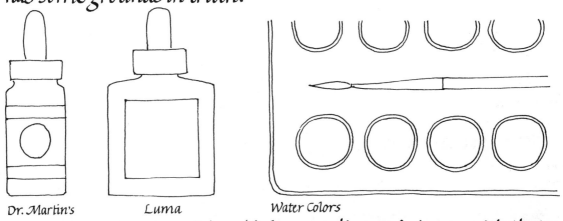

Dr. Martin's Luma Water Colors

Colored inks may disappoint you with their weak colors. Persist in search of "Dr. Martin's" and "Luma" bottled water-based dye. Their luminous quality and tremendous range of colors will inspire you. They flow easily and mix with each other. Start with Scarlet, Mahogany, or Slate Blue, adding others as you need them. At the same time, a watercolor set is a sensible investment for drawn-and-filled-in ornamentation. Pelikan's 24-color set includes a pleasant imitation gold paint—a simple way to experiment with flat gold effects before you venture into the expensive materials and special techniques of traditional gilding.

Different lettering projects require different papers. In addition to the Document paper described in the preceding section, calligraphers will find <u>Arches Satine</u> smooth and fine. A heavier one-sided paper, <u>Rives BFK</u>, made primarily for lithography, works well for larger calligraphy. Both papers have a good surface for colored ink. Books and other two-sided projects rely on a number of handmade papers available from art stores, catalogs, calligraphy suppliers, and paper distributors. Cultivate your local art supply store; the staff there often know more about calligraphy materials than most calligraphers.

At this point you can best continue your development by reaching out to other calligraphers. Join a local calligraphers' group, or organize one. Share your problems and solutions, put on exhibitions, promote local awareness of calligraphy. Join a regional group; find out about workshops, demonstrations, courses, and exhibitions that might be worth travelling to. Join a national group and read their newsletter to follow the activities of prominent contemporary scribes and teachers, the emergence of new techniques and theories, and the group's interpretation of recent publications and events. Finally, read everything you can get your hands on: library books, craft magazines, pamphlets, supply catalogs. This contact with the visual and intellectual ideas of other calligraphers will stimulate you to define and refine your own unique personal style.

As you move up the ladder of technical expertise, you venture backward in historical time to the very origins of your craft thousands of years ago. The felt pen of 1980 derives from the fountain pen of 1820, which leads back to the steel pens of 1600, which grew out of the quill pen of A.D 100 or earlier. This hand-cut quill is still the instrument of choice for the finest calligraphy. Like the virtuoso oboeist's hand-cut reeds or the prima ballerina's hand-sewn slipper ties, the care that the master calligrapher puts into his work begins with painstaking precision in making the pen.

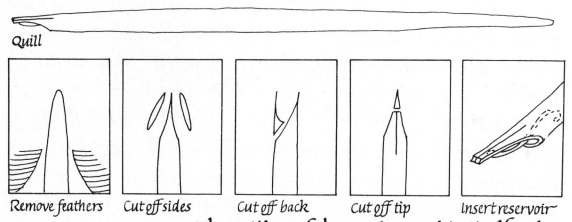

Quill

Remove feathers Cut off sides Cut off back Cut off tip Insert reservoir

The cutting of the pen is an art in itself. The flight feathers of swans represent the best balance of strength and flexibility. Arm yourself with a bundle of quills to learn on and a very sharp penknife or scalpel. First strip away all the soft, feathery bits from the shaft. Cut two pieces off the sides and one off the back to make a pointed pen. On a wooden surface or thick paper pad, cut off the pointed tip at the width you need. Slit the end. Insert a watch-spring or strip of flat wire as a reservoir.

The proper ink with the quill pen is India Ink
ground down fresh daily with distilled water from a solid stick
of hardened ink. This is done on an unglazed bowl or slab. The pen
reservoir is filled with a dropper or a brush from the side.

Writing with a quill pen on vellum is both
a tactile and a visual pleasure. The pen glides over the velvety
surface. The vellum seems almost three-dimensional; the letters sink
in and stand out at the same time. The flexible pen subtly en-
hances the shape of each stroke.

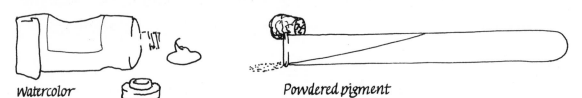

Watercolor Powdered pigment

Color is applied with brush or quill pen.
To achieve the most durability and brightness, mix powdered
pure pigments with distilled water and a small amount of egg
yolk. For less formal ornament or practice work, use tubes
of water color. If you have trouble handling the transparent
paint, add Chinese White in small amounts to give it a flat,
even texture. The more white you add, however, the weaker
and more powdery the hue will get.

Vellum encourages the application of gold
leaf. (Even heavy papers do not guarantee a strong enough foun-
dation to resist buckling and wrinkling.) Gold leaf differs from
gold paint in its reflection of light. Gold leaf ornament consists
of a solid but thin layer of gold pressed onto a slightly raised
layer of a chalky paste called gesso, to give the smooth, shiny

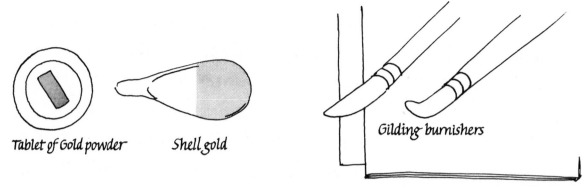

Tablet of Gold powder Shell gold Gilding burnishers

illusion of heavy gold plating or solid gold. The burnished surface catches the light and reflects it back smoothly. Gilded letters look their best in low light, where they can gleam out from a dim page. Gold paint, on the other hand, is a suspension of gold powder in distilled water. The minute flecks of gold send light back in an even, overall, glittery texture.

There are two ways to learn these techniques. By far the best is to learn direct from someone who has mastered the many subtle problems of special materials, tools, and techniques. The craft of cutting a quill pen, lettering on vellum, and gilding with gold leaf has passed through many generations of craftsmen; many skilled minds have worked on these processes. You can cut short the tedious stretches of trial and error by apprenticeship or by participation in workshops, demonstrations, and master classes. Second choice is a careful study of the detailed instructions in The Calligraphers Handbook, C.W. Lamb, ed., (Faber).

Finally, while learning from books and from other advanced calligraphers, learn to learn from yourself. Relax and scribble with a felt pen. Look over some of your first, fresh ideas. Calligraphy can get too precise; loosen up and enjoy it.

chapter about the techniques of APPLYING ink to paper would be incomplete without mentioning the occasional necessity for REMOVING that ink when you make a mistake. Mistakes —real errors noticeable to the average reader—happen to beginner and master craftsman alike. Mistakes do not detract from your value as a calligrapher. As in other arts, the important thing is how you react to and recover from the mistake.

There is no one prescribed way to deal with errors; they come in different sizes, with different inks, on different surfaces, and of varying degrees of noticeability. You size up the situation, make a diagnosis, and decide whether you can cure the ailment without killing the patient.

An error in layout is fundamental, and usually hard to put right. If a line is incorrectly measured, if you notice an 82° where you thought you had 90°, or if your text shows signs of wildly overrunning its boundaries, STOP. Don't try to patch it up. Start the piece over, with better underpinnings.

If your calligraphy suffers from repeated errors in layout and you find yourself laboriously executing a piece in final form to get it right, you may be the kind of person who needs to do more work at the rough-draft stage of design. Use felt pens and tracing paper to show lettering. Don't try to work neatly; try to discover any major problems in overall design.

Smaller errors of the wandering mind—

omission **now is th time for all**

Duplication **now is the the time for**

Transposition **now is time the for all**

Mis execution **now is th'e time for all**

omission, duplication, transposition, and misexecution — can be treated with one of two approaches ; lift the ink off or cover it up. Your choice depends on the kind of ink and paper involved, and on the purpose of the piece of calligraphy.

An error in a piece of original calligraphic artwork for reproduction is easy to correct by covering with a thin layer of white paint and then relettering. Liquid Paper works well for letter and word corrections. Give it ample time to dry or your pen will scrape up small flakes of paint and clog up. For greater detail, try Designer's White or Pro White with a very small watercolor brush. These paints, when dry, have a "workable" surface; that is, the ink will not bead up or dissolve them when you reletter on top of them.

Some fountain pen inks on some papers can be removed by ink eradication kits available in stationery stores. They consist of bleach and a neutralizer to stop the bleach. The corrected area becomes unworkable — that is, the ink will blot and spread when you try to reletter over the same spot.

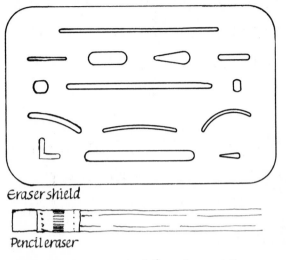

Eraser shield

Pencil eraser

Fountain pen ink on a few papers and India Ink on most can be re-moved by abrasion. Rub hard with a "Pink Pearl" or pencil-end eraser, protecting the nearby ink and paper with an eraser shield. Thick, hard-surfaced papers are the most tolerant of this treatment. India Ink will erase more readily than fountain pen ink that soaks down into the paper fibers.

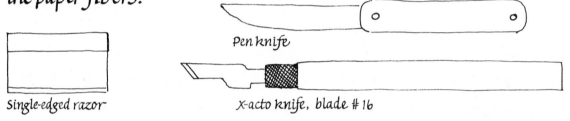

Single-edged razor

Pen knife

X-acto knife, blade #16

Perhaps the best correction technique is to shave off the India Ink and a thin layer of the paper or the paper surface with it. Its a tricky, finicky technique, demanding patience and a light hand, but once you master it you can

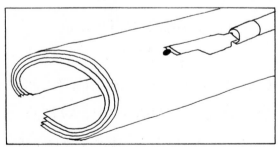

Roll sheet firmly with several others to prevent creases Outline areas that need sharp boundaries

perform many spectacular rescues & redeem much valuable work.

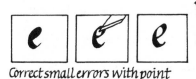

Correct small errors with point

Very small corrections can sometimes be made with the sharp point of a knife. Rub firmly with a soft eraser to clean out any remaining ink from the paper fibers. Do not reletter.

Scrape back and forth

Some vellums will tolerate having the ink and surface scraped gently with a firm flat blade held at 90°. Rub in a little pounce (surface-preparation powder) afterwards, to restore the surface to its original texture.

If you have the misfortune to make a truly uncorrectable mistake while writing in a bound book, you will have to remove the page. In a blank book, cut extremely carefully through the sheet at the fold where it is bound and take out both the spoiled page and the blank sheet connected to it. If you do not want to lose two pages for one mistake, cut the spoiled sheet off, leaving a ⅜" stub of paper at the binding. Cut a new sheet out of the back of the book, leaving a ⅛" stub, or make a new page out of matching paper. Glue the blank sheet to the ⅜" stub.

times two two times two times

Some letter styles lend themselves to easy correction of errors of transposition. Why scrape off and reletter a whole word when the alteration of a few strokes can change it into the word you want? Don't overreact when you make a mistake. Stop and pencil in the correction to see how much is really wrong.

For a reassuring view of errors, see Appendix A of Writing and Illuminating and Lettering by Edward Johnston.

ne calligrapher's tool remains to be mastered by practitioners of the craft on every level—the common, everyday, garden-variety, wooden "lead" pencil. No matter how new you are to calligraphy, you must learn two special techniques of making the pencil make your work easier.

Start with a sharp pencil of good quality, #2 or 2½ or HB hardness. To draw guidelines, pull the pencil along lightly but firmly, pointing it almost toward where you're going, and gradually roll the pencil between thumb and fingers.

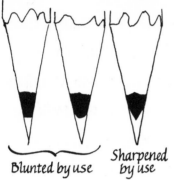

Blunted by use Sharpened by use

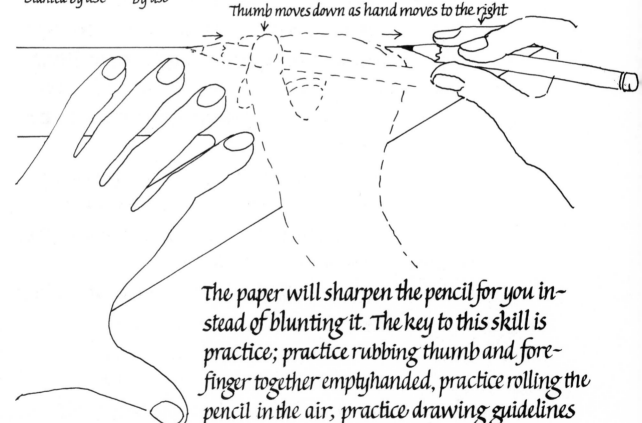

Thumb moves down as hand moves to the right

The paper will sharpen the pencil for you instead of blunting it. The key to this skill is practice; practice rubbing thumb and forefinger together emptyhanded, practice rolling the pencil in the air, practice drawing guidelines

with a triangle or straightedge as shown in the illustration. It's no harder than learning to knit, crochet, shuffle cards, dial a telephone, or eat with chopsticks. And it's worth it; as you get into designing pieces of calligraphy that need precise and extensive layout you'll have the pleasure of working with a consistently sharp-pointed pencil without having to stop frequently to sharpen it.

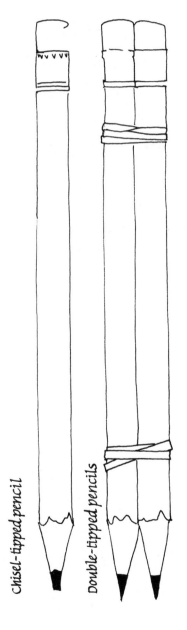

Chisel-tipped pencil

Double-tipped pencils

The second pencil technique to learn is how to make a pencil-pen. When you need an accurate forecast of word placement or letter spacing before inking in, write with a pencil shaved down to a chisel tip so that it approximates the broad-edged pen. Keep several chisel tipped pencils (made from regular, oversize, and carpenter's pencils) on hand and get into the habit of pencilling in any crucial spacing problems before you commit yourself to ink. Don't rely solely on your luck!

For very large letters, stick two pencils together with a rubber band or masking tape, and write with large, smooth whole-arm motions.

Remove all pencil marks with Art Gum or Magic erasers.

Magic Eraser

ART
GUM

BASIC BIBLIOGRAPHY

Anderson, Donald. *The Art of Written Forms*. New
 York: Holt, Rinehart, and Winston, 1969.
Eager, Fred. *The Italic Way to Beautiful Handwriting*.
 New York: Collier, 1967.
Johnston, Edward. *Writing and Illuminating and
 Lettering*. London: Pitman, 1905.
Lamb, C. W., ed. *The Calligrapher's Handbook*.
 London: Faber & Faber, 1956.
Shepherd, Margaret. *Learning Calligraphy*. New
 York: Collier, 1977.

NATIONAL ORGANIZATIONS

Society of Scribes
Box 933
New York, N.Y. 10022

Society of Scribes and Illuminators
% The Federation of British Craft Societies
43 Earlham Street
London WC2 England

II

New Alphabets From Old

The test of a vocation is the love of the drudgery it involves.

Logan Pearsall Smith

Practice is the best of all instructors.

Publius Syrus

Alphabets, like human faces, exist in thousands of forms, each slightly but uniquely distinct from the others. Just as your face can be classified within its general national type by describing each of its features, so an alphabet can be classified by first noting its general historical appearance and then specifying in great detail its individual features. Thus, when you decide to use Italic letters, the definition of the Italic style still leaves you a certain degree of latitude in your choice of pen angle, letter angle, letter width, angularity, boldness, and serif shape.

Calligraphers almost always begin their study of letters by learning to recognize and repro-duce the major alphabet styles that have come to us from our Graeco-Roman heritage. Since these styles represent a consensus of many historical samples, since teachers have different and overlapping categories for these styles, and since several names exist for each style, the beginning calligrapher may wonder if the list of alphabets to be learned is endless. It only <u>seems</u> endless; while the variations go on and on, the main categories number under a dozen.

When you learn these alphabet styles, you are laying the foundation for all future explor-ation and growth. The crucial thing is not

Varieties of Italic lettering, from Arrighi, Tagliente, Society of Scribes, Arthur Baker.

the finer points of nomenclature but your basic understanding of how alphabet styles relate to each other. What makes Gothic different from Italic? What do they have in common? How did Bookhand grow out of Celtic, and Celtic out of Roman?

ROMAN ABCDEFGHIJKLMN

CELTIC abcdefghijkl

Gothic abcdefghijklmnopqrst

Italic abcdefghijklmnopqrst

Bookhand abcdefghijklmnopqrs

The five major historic hands

What makes these five basic hands so distinct? First, HISTORY. Each one was, for at least two hundred years, seen by its scribes and readers as the true form of the alphabet. (This cultural egocentricity partly accounts for the imprecision of alphabet names. Scribes in Renaissance Italy did not call their own distinctive style "Italic" any more than they called their own age "The Renaissance"; both are the retrospective designations of a later age.)

Second, the basic historic styles are important because of POLITICS. They not only represent great cultural periods of self-awareness but also were themselves instruments of national or religious aggrandisement and self-justification. These letters were selected and named to distinguish them from their

predecessors and disparage their neighbors. Thus, the medieval letter of northern Europe was not only superceded by the Italic and Bookhand of Renaissance scribes in Italy; it was also given by them the most disdainful name in their power — "Gothic," meaning "grotesque" and "barbarian."

Third, the distinction is VISUAL. While there is some latitude in interpreting the mass of historical models, and while no one calligrapher's model has the final say, the major historical hands do look fundamentally different from each other.

The uniqueness of each style is briefly examined in the following 22 pages; these short lessons and master sheets will help you get started lettering if you are a beginner, give you practice and review if you are a student, simplify your growing repertoire of styles if you are a calligrapher, and add a few letter variants and visual shortcuts if you are a master craftsman. At all levels, spend enough time with the basic alphabet styles to insure a firm foundation for further experiments.

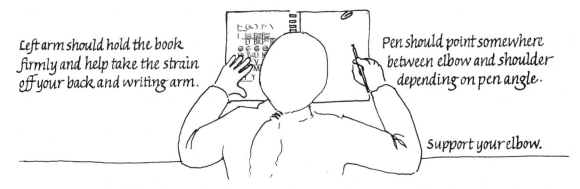

Left arm should hold the book firmly and help take the strain off your back and writing arm.

Pen should point somewhere between elbow and shoulder depending on pen angle.

Support your elbow.

Work through the basic alphabets this way; lay a piece of practice paper over the Guideline Sheet, and

fasten with a paperclip. The guidelines should show faintly through your practice paper.

If your hand slips off the edge of the book as you near the bottom of the page, support your hand with a thick pad of paper or a thin book. Work on a desk surface that tilts toward you, if possible. It is, however, much more important at this point to provide good, solid support for your elbow.

DO NOT write directly on the Guideline Sheet and use it up; then you will have to stop and draw your own guidelines onto a blank sheet every single time you want to practice thereafter. Save yourself work.

DO NOT attempt to practice without any guidelines at all because you will not be able to keep the letters all the same size. Repetitive practice is best.

DO NOT lay the practice paper over the Master Sheet and trace the letters directly because then you will always need that crutch. You need eye training, not just hand exercise. Cultivate hand-eye coordination.

You may run Xerox copies of the Guideline Sheets if you prefer. You may, if you are having trouble evaluating your own finished practice letters, lay them over the Master Sheet for the purpose of comparison only.

When you are ready to practice, choose a pen suited to your level of expertise. If you are in any doubt, aim low; it is better to breeze along with slightly reduced fineness than to toil away gracelessly with a pen that you just can't manage.

If you are a beginner, you may be making an eye-opening discovery at this point. All the thicks and thins in a letter are put in by the pen. You don't have to learn where they go. All you have to learn is how to hold and move the pen correctly for each alphabet style.

TERMINOLOGY *of* THE PEN

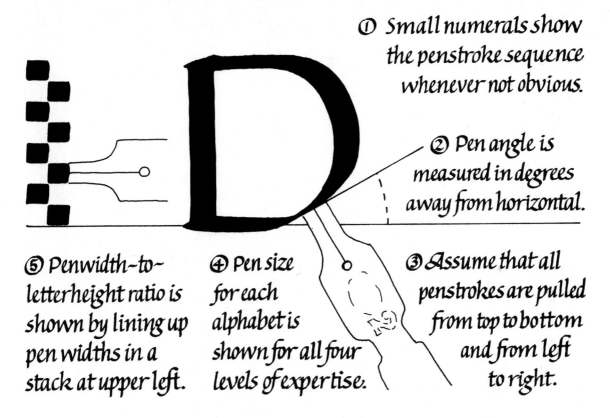

① Small numerals show the penstroke sequence whenever not obvious.

② Pen angle is measured in degrees away from horizontal.

⑤ Penwidth-to-letterheight ratio is shown by lining up pen widths in a stack at upper left.

④ Pen size for each alphabet is shown for all four levels of expertise.

③ Assume that all penstrokes are pulled from top to bottom and from left to right.

Start with Roman or Bookhand if you are patient and self-disciplined, with Celtic if you are inventive, with Gothic if you seek instant gratification, and with Italic if you want your study of calligraphy to influence your own handwriting.

If you want more historical background and design advice than what is given here, study _Learning Calligraphy_, by Margaret Shepherd. Collier, 1978.

ROMAN CAPITALS,

WHILE THE MOST FAMILIAR
LETTERS, ARE ALSO THE MOST DIFFICULT ·
THEY CANNOT BE SUMMED UP IN A FEW
RULES, AS EACH LETTER HAS ITS OWN VISUAL
IDENTITY · THE ONE PRINCIPLE UNITING
THE ROMAN ALPHABET IS PROPORTION ·
STUDY THE MASTER SHEET, AS WELL AS ANY
OTHER ROMAN INSCRIPTIONS YOU CAN
FIND, TO SEE WHICH LETTERS HAVE SIMI-
LAR HEIGHT ~ TO ~ WIDTH RATIO · THEN
NOTE WHICH LETTERS ARE DONE WITH
THE SAME PEN ANGLE · TRY GROUPING
THE ALPHABET INTO OTHER CATEGORIES :
DIAGONAL, RECTANGULAR, OR ROUND
SHAPE; ONE, TWO, THREE, OR FOUR~STROKE
LETTERS; TOP~ OR BOTTOM~HEAVY LET-
TERS · PRACTICING IN THESE AND OTHER
CLASSIFICATION GROUPINGS WILL GIVE
YOU INSIGHT INTO THE CLASSIC SUBTLETY OF THE ROMAN LETTER·

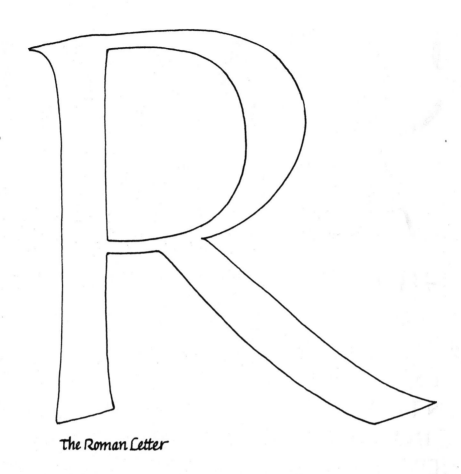

the Roman Letter

ROMAN LETTERS DEMAND ATTENTION TO
DETAIL· NOTICE THE CHARACTER OF EACH ONE.
HOW DO CURVED SECTIONS OVERLAP STRAIGHT
ONES? WHERE DO MID~STROKES JOIN THE
VERTICALS —ABOVE OR BELOW THE TRUE
CENTER? WHAT INGREDIENT PARTS ARE
BORROWED FROM OTHER LETTERS? WHICH
STROKES ARE LIMITED TO PRESCRIBED LINES
OR CURVES AND WHICH ALLOW SOME LATITUDE?
GET ACQUAINTED WITH THE PERSONALITY OF
EACH LETTER TO WORK WITH, NOT AGAINST, IT·

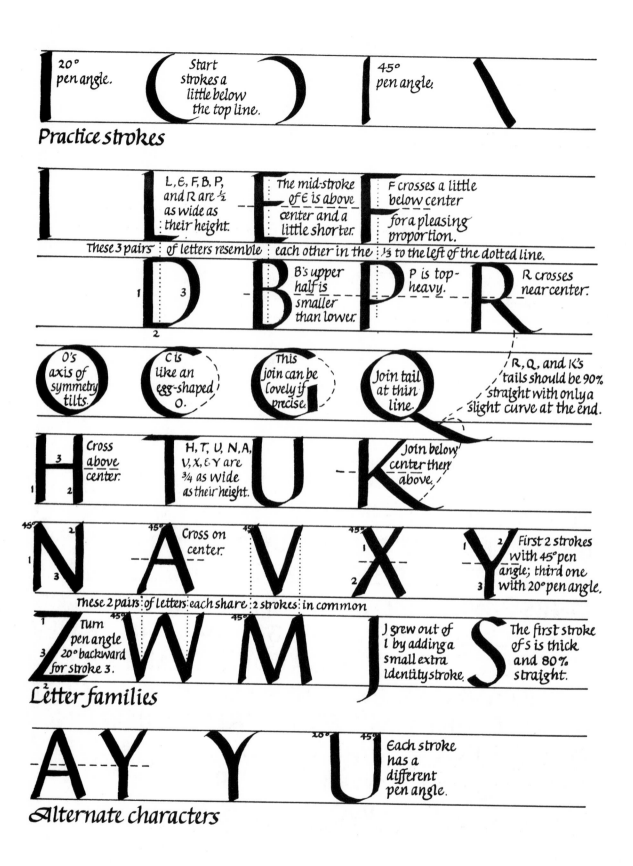

Practice strokes

20° pen angle.

Start strokes a little below the top line.

45° pen angle.

L, E, F, B, P, and R are ½ as wide as their height.

The mid-stroke of E is above center and a little shorter.

F crosses a little below center for a pleasing proportion.

These 3 pairs of letters resemble each other in the ⅓ to the left of the dotted line.

B's upper half is smaller than lower.

P is top-heavy.

R crosses near center.

O's axis of symmetry tilts.

C is like an egg-shaped O.

This join can be lovely if precise.

Join tail at thin line.

R, Q, and K's tails should be 90% straight with only a slight curve at the end.

Cross above center.

H, T, U, N, A, V, X, & Y are ¾ as wide as their height.

Join below center then above.

Cross on center.

First 2 strokes with 45° pen angle; third one with 20° pen angle.

These 2 pairs of letters each share 2 strokes in common

Turn pen angle 20° backward for stroke 3.

J grew out of I by adding a small extra identity stroke.

The first stroke of S is thick and 80% straight.

Letter families

Each stroke has a different pen angle.

Alternate characters

Design felt pen, Osmiroid or Platignum fountain pen with B4 nib, Mitchell pen with # 1 nib, or quill cut to 3/16 ". Pen angles of 20° and 45°.

Lay practice paper over Guideline sheet & practice letters in groups of letter families.

CELTIC is

the most distinctive of a whole range of book-writing hands that proliferated after the roman letter, & the most useful. the overlapping styles of the uncials and half-uncials of the "dark ages" can be gathered together and reinterpreted for modern eyes under the celtic style. this alphabet includes a wealth of alternate letter forms, unified into a coherent style by the basic bulging, elastic quality of the shapes & by the unique celtic serif.

the celtic serif is made of 2 strokes: 1 straight

& then one curved, superimposed over one another.

the celtic alphabet encourages calligraphic improvisation.

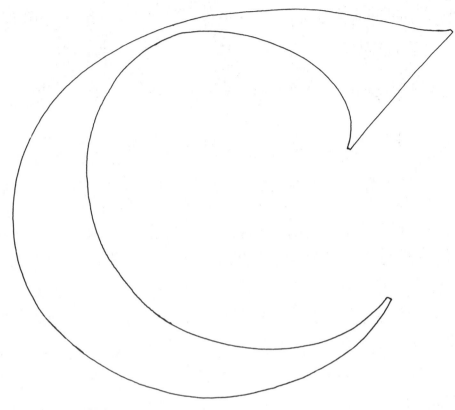

The Celtic letter

CELTIC LETTERS FORCE YOU to make choices. YOU CAN USE A thick pen OR A thin pen FOR <u>heavy letters</u> OR <u>LIGHT LETTERS</u>. YOU CAN MAKE CELTIC LETTERS <u>simple and unadorned</u> OR YOU CAN make them <u>ELABORATE AND COMPLICATED.</u> YOU CAN VARY the SPACING FROM <u>OPEN</u> to <u>CROWDED</u>. AND YOU CAN choose FROM sometimes half A DOZEN ALTERNATE FORMS OF EACH letter, FOR A UNIQUE style.

I ∩ 2 ᘓ J

Practice strokes

A A A A A B B C

D D E E F G G g

H H H h i j k L L m

m n n n o p p p q

r r R s ᘓ t u u v

w w w x x y y z

Develop your own individual Celtic style by choosing from the many alternate letters above.

Design felt pen, Osmiroid or Platignum fountain pen with B4 nib, Mitchell pen with #1 nib, or quill cut to 3/16". Pen angle of 30°

Lay practice paper over Guideline Sheet & practice letters in groups of letter families.

Gothic

is a simple alphabet to learn— it only looks <u>indecipherable</u>. Just keep the black strokes and the white spaces absolutely equal and even. Space between words is one letter wide; space between lines is one letter high. The word above, and much of this page, should look like this when you cover the tops and bottoms: ||||||

The Gothic style offers the calligrapher a philosophical challenge: how to take one basic shape and make 26 letters out of it. Add and subtract just two basic ingredients, the box and stripe. That's all there is to learning Gothic.

The Gothic Letter

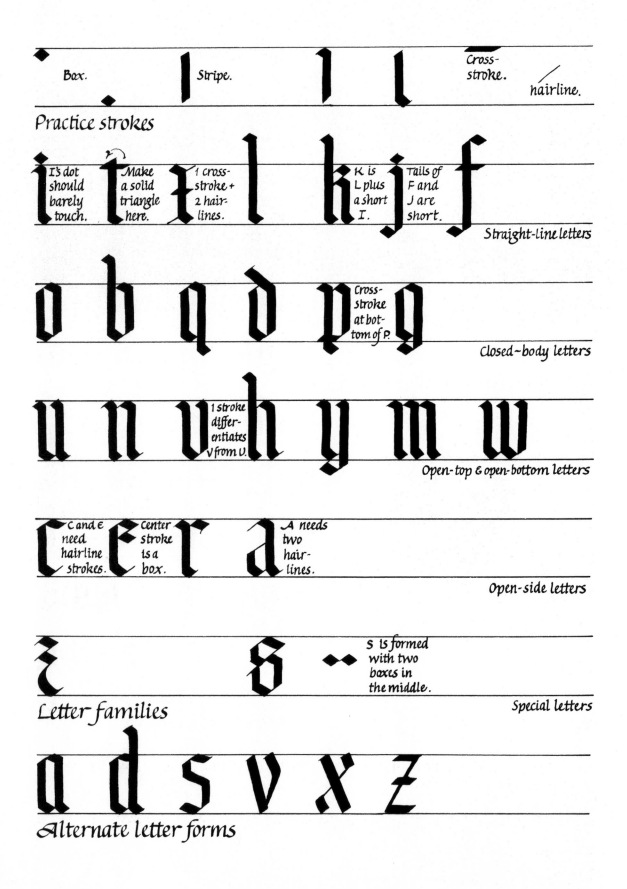

Box. Stripe. Cross-
 stroke. hairline.

Practice strokes

I's dot Make 1 cross- K is Tails of
should a solid stroke + L plus F and
barely triangle 2 hair- a short J are
touch. here. lines. I. short.
 Straight-line letters

 Cross-
 stroke
 at bot-
 tom of P.
 Closed~body letters

 1 stroke
 differ-
 entiates
 v from U.
 Open-top & open-bottom letters

C and E Center A needs
need stroke two
hairline is a hair-
strokes. box. lines.
 Open-side letters

 s is formed
 with two
 boxes in
 the middle.
Letter families Special letters

Alternate letter forms

Design felt pen, Osmiroid or Platignum fountain pen with B4 nib, Mitchell pen with #1 nib, or quill cut to ³/₁₆". Pen angle of 45°.

Lay practice paper over Guideline Sheet and practice letters in groups of letter families.

bookhand

is deceptively simple.
It looks easy, because
it resembles the lower-
case Roman that con-
stitutes 90% of what we
read every day. It's too
familiar to scare us.

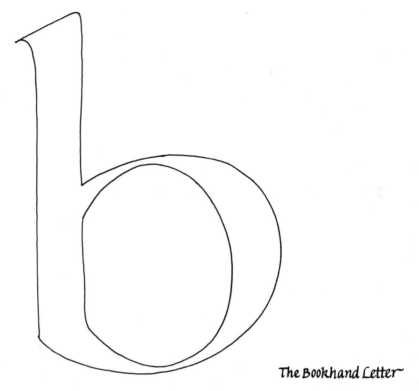

The Bookhand Letter

Bookhand makes you see that not only is every letter unique but also the spaces between the letters are all different.

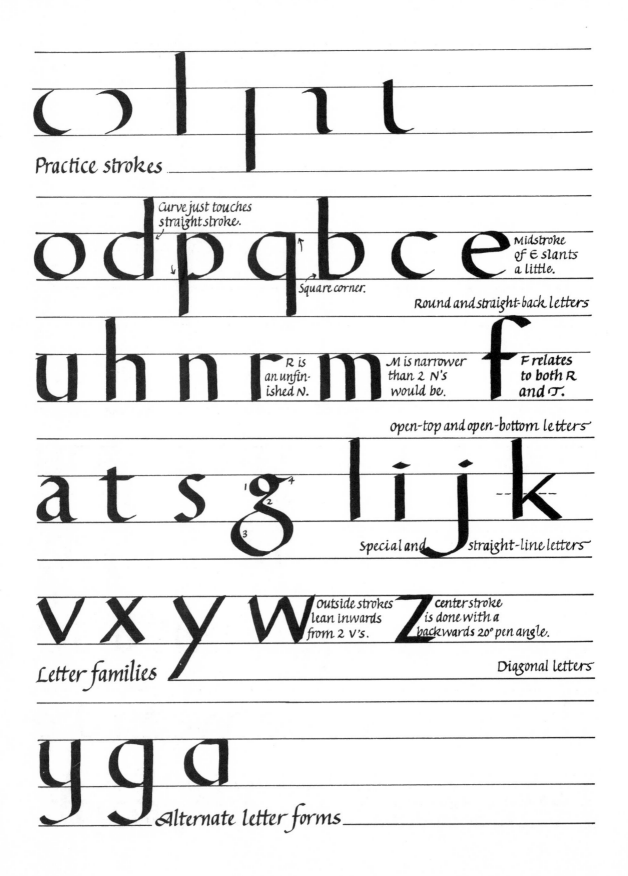

Practice strokes

Curve just touches
straight stroke.

Square corner.

Midstroke
of E slants
a little.

Round and straight-back letters

R is
an unfin-
ished N.

M is narrower
than 2 N's
would be.

F relates
to both R
and T.

open-top and open-bottom letters

Special and straight-line letters

Outside strokes
lean inwards
from 2 V's.

center stroke
is done with a
backwards 20° pen angle.

Letter families

Diagonal letters

Alternate letter forms

Design felt pen, Osmiroid and Platignum fountain pen with B4 nib, Mitchell pen with #1 nib, or quill cut to 3/16." Pen angles of 20° and 45°.

Lay practice paper over Guideline Sheet & practice letters in groups of letter families.

Italic

lettering comes from a blending of two traditions—the formal, polished letters of the major historical hands and the rapid, functional scrawl of every~ day records & correspondence. Italic letters have some of the individuality of Bookhand, with the uniformity of Gothic.

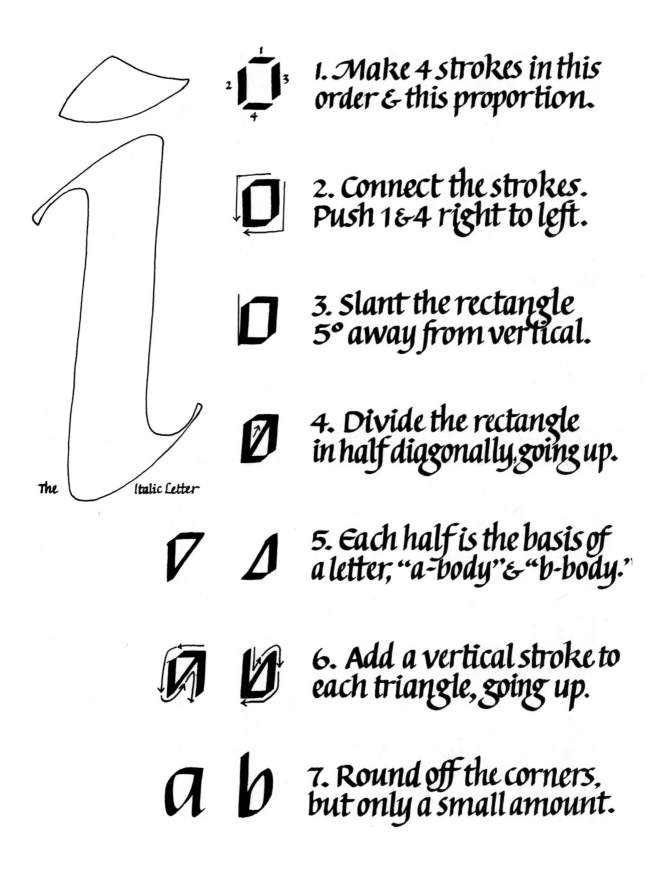

The Italic Letter

1. Make 4 strokes in this order & this proportion.

2. Connect the strokes. Push 1 & 4 right to left.

3. Slant the rectangle 5° away from vertical.

4. Divide the rectangle in half diagonally, going up.

5. Each half is the basis of a letter, "a-body" & "b-body."

6. Add a vertical stroke to each triangle, going up.

7. Round off the corners, but only a small amount.

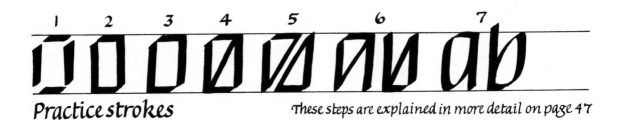

Practice strokes

These steps are explained in more detail on page 47

This curve resembles upper corner of A.

acdegquyf

'a-body' letters

bhpnmjkrtli

This curve resembles lower corner of B.

'b-body' letters and 1-line letters

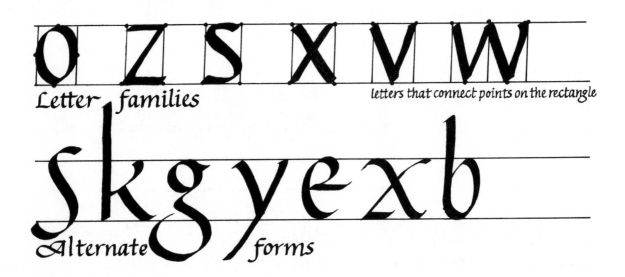

Letter families

letters that connect points on the rectangle

Alternate forms

Design felt pen, Osmiroid or Platignum fountain pen with B4 nib, Mitchell pen with # 1 nib, or quill cut to 3/16": Pen angle of 45°, letter angle of 5°.

Lay practice paper over Guideline Sheet & practice letters in groups of letter families.

These then are the most important historical styles, five general categories into which most calligraphy done between 100 B.C. and A.D. 1600 can be assigned. Some minor historical hands have been relegated into one of the categories, for a number of practical and philosophical reasons.

UNCIAL and half-uncial in their authentic historical forms are sometimes difficult for the modern eye to read, and are much more interesting historically as the roots of other styles than visually for their qualities as coherent and clearly identifiable scripts. They contribute many alternate letters. Rotonda and Batarde can be derived very easily from Gothic. Carolingian minuscule in its original ninth-century form presents so many problems of extra or missing letters for 20th-century writing, that the scribe who debugs and updates this hand will find himself "re-inventing the wheel"—arriving after much thought and labor at the Bookhand alphabet. And two post-Renaissance broad pen styles, Ronde and Legende, are so closely related to type designs*of the time as to be almost stepchildren; they are shown in the next chapter under the guardianship of Celtic.

Any other favorite and familiar styles you miss may just be called by other names. Check the list on page 74. Practice and practice the five major styles until you feel comfortable recognizing and executing them.

*Copperplate and Civilité

ow you are ready to turn this basic array of five alphabets into a huge resource bank of alphabet variations. You do not have to learn any more basic styles; you will need only a firm grasp of the five major hands, patience, and a fundamental inquisitiveness about the infinite potential for creativity with the broad-edge pen.

Start this way. Read very carefully the six methods of variation described on the next two pages.

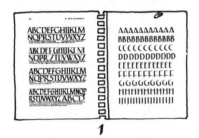
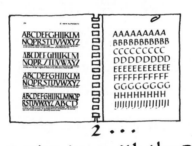
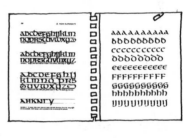

1
2 . . .

Beginning with the Roman variations,* paperclip a sheet of practice paper over the Guideline Sheet. Fill up the practice paper with Variation 1, repeating each letter several times and grouping the letters into letter families to understand them better. Clip on a fresh sheet of practice paper and give the same treatment to Variation 2. When you have done all eight Roman variations, go back to the original Roman Master Sheet for review. Then go on to the Celtic set of alphabet variations and repeat the process. * see page 29.

You'll find that not only do you build up a repertoire of appealing alphabets but also you become better acquainted with the basic styles and with the pen itself.

VARIATION 1

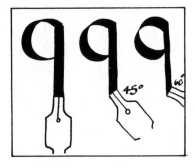

VARIATION 2

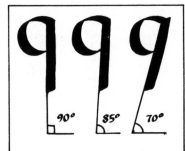

VARIATION 3

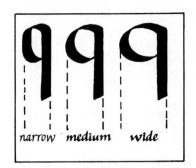

Nothing shows the unique character of the calligraphic letter more than the way a change of the PEN ANGLE alters the alphabet style. Subtly but discernably, the relative thickness of the strokes is altered. The emphasis can be on horizontal, vertical, or diagonal, depending on what pen angle you choose for the alphabet. Since even a slight change of angle alters the style, don't change angles in the middle of an alphabet!

The second set of variations involves a change in LETTER ANGLE. Practice alphabets with varying amounts of slant—or try a slanted alphabet like Italic without slant. Notice how a slight change in angle makes a big difference in alphabet style. Keeping the same slant throughout an alphabet is not as easy as it looks; practice will train hand and eye.

Almost the simplest variation you can make is a change in LETTER WIDTH. At this point you may find that the identity of the basic alphabet styles becomes imprecise. A widened Roman R, for instance, resembles a Celtic R, while a narrowed Bookhand H resembles a Gothic H. Start with a fairly lightweight letter (see Variation 5) for easiest pen maneuverability.

VARIATION 4 VARIATION 5 VARIATION 6

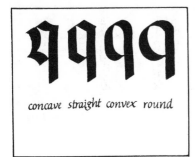

concave straight convex round

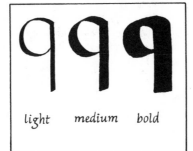

light medium bold

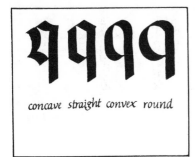

medium descender, long descender, hairline serif 1-stroke serif short descender, heavy serif

For fascinating results, try varying the ANGULARITY of an alphabet. To do this — and to know how to recognize it — try thinking of the letter as an airtight container. Pump the air out for a concave appearance. Pump air in to make the letter rounded. Use the closed letters (O, Q, P, for example) as models for the open ones. Work with a heavy pen for contrast.

There are two ways to achieve the next set of variations in BOLDNESS, the ratio between pen width and letter size. First, change the pen width, trying all your pens with a half-inch letter as shown above. Next, use one pen width, varying the letter size. (As your letter gets bolder, the curves & joins may get harder to make.

Unless otherwise noted, use Design felt pen, fountain pen with B4 nib, #1 Mitchell nib, or 3/16" quill.

An enormous number of variations is open to you with SERIF WEIGHT AND SHAPE and SHAPE OF AS- CENDERS AND DESCENDERS. These make up a general category of changes that do not affect the letter body itself. Serifs can make a big difference to the Roman capitals, while the Celtic letter body gener- ates widely varied styles.

ABCDEFGHIJKLM
NOPRSTUVWXYZ

The basic Roman alphabet, reviewed on pages 30~33. You may find this version slightly bolder; the letter size has been reduced ½ pen width to fit the space. Q's tail is shown next to O.

ABCDEFGHIJKLM
NOPR STUVWXYZ

Variation 1. A very flat PEN ANGLE makes an Art Deco style. Use a very steep pen angle where you normally have a 45° angle. Exaggerate the distance of cross-strokes above or below the center.

ABCDEFGHIJKLM
NOPRSTUVWXYZ

Variation 2. A 5° LETTER ANGLE makes a slanted capital that harmonizes with Italic. Keep the PEN ANGLE at a constant 45°.

ABCDEFGHIJKLMNOP
RSTUVWXYZ ABCD

Variation 3. Changes in LETTER WIDTH shrink or stretch letters to fit space. Alter PEN ANGLE if curves and joins seem awkward. The two changes shown here will help you learn the historical styles called Rustica and Quadrata, offshoots of classical Roman.

PEN ANGLES; Roman 20°, 45°; Variation 1 0°, 45°, 90°; Variation 2 45°; Variation 3 45°, 20°.

ABCDEFGHIJKLM NOPQRSTUVWXYZ

Variation 4. Blow ⟍ the letter up to fit a box shape. Notice the new join; be accurate. You may come up with alternate designs for K, M, N, W, and Y. Or try a "Grecian" version with a diamond-shaped letter: ABⅭDEFGHIJKLMNOPQRSTVVWXYZ

ABCDEFGHIJKLM NOPQRSTUVWXYZ

Variation 5. A ⟍ light variation on BOLDNESS. Enlarge the ends of each stroke by smoothly turning the pen to a flatter angle while you are doing the stroke. Use a Chizl felt pen, fountain pen with B2 nib, Mitchell pen with #3 nib, or quill cut to ⅛".

ABCDEFGHIJKLM NOPQRSTUVWXYZ

Variation 6. A ⟍ thick SERIF made with a separate stroke gives the Roman letter emphasis but takes away elegance. Be precise with length of serif & junction with stem.

ABCDEFGHIJKLMNO PRSTUVWXYZ

Variations 6 + 1 + 3. You can imitate "Old West" poster styles by turning the PEN ANGLE to 90°, making the letters all ½ as wide as their height, exaggerating the SERIFS, & turning the PEN ANGLE to 45° to add the decorative diamonds. (Try them on basic Roman, too.)

PEN ANGLES; *Variation 4* 25°, *Variation 5* 20°, 45°, *Variation 6* 20°, 45°, *Variations 6+1+3* 90°, 45°

abcdefghijklm
nqprstuvwxyz

The basic Celtic alphabet, reviewed on pages 34~37.

abcdefghijklm
nqprstuvwxyz

Variation 1. Use a flat PEN ANGLE to make a more archaic, historically cor-rect letter.

abcdefghij
klmnq prs
tuvwxyz

Variation 3. WIDENING the Celtic letter gives greater scope for its elasticity and coils.

AHKNrY

Variation 4. To make Celtic more ANGULAR choose alternate characters from the many differ-
ent ones available. Don't tamper with the fundamental roundness of the alphabet.

PEN ANGLES: Celtic 45°; Variation 1 10°; Variation 3 45°; Variation 4 45°

abcdefghijklm
nopqrstuvwxyz

Variation 5. A ▲ BOLD Celtic alphabet. Use Mitchell nib #0 or quill cut to ¼."

abcdefghijklm
nopqrstuvwxyz

Variation 6. Lengthen the ascenders and descenders for a less imposing, more ● readable style.

abcde ● hiklm
norstuvw
xyzgpqjʒ

Variation 6. Spread the letters
out & make ⟨a⟩ loop on ascenders
& descenders to make Ronde.

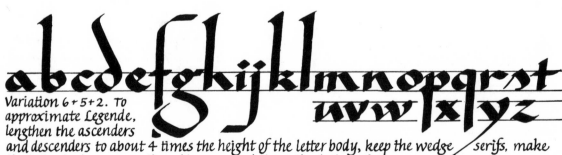

abcdefghijklmnopqrst
uvwⵏxⵏyz

Variation 6 + 5 + 2. To
approximate Legende,
lengthen the ascenders
and descenders to about 4 times the height of the letter body, keep the wedge ╱ serifs, make
the letter body very small and heavy, and slant the letter 5°.

PEN ANGLES: *Variation 5 45°; Variation 6 45°; Variation 6 45°.*

PEN ANGLE: *Variation 6 + 5 + 2 45°.*

abcdefghijklmnopq

rstuvwxyz
The basic Gothic alphabet, reviewed on pages 38~41.

abcdefghijklmnop

qrstuvwxyz
Variation 1. Gothic forms, interpreted with a flat PEN ANGLE.

abcdefghijklmnopq

rstuvwxyz
Variation 2. A slanted Gothic letter.

abcdefghijklm

nopqrstuvwxyz
Variation 3. With a WIDE letter, keep inside and outside spaces the same width.

PEN ANGLES: Gothic 45°; Variation 1 0°; Variation 2 45°; Variation 3 40°.

abcdefghijklmnopq
rstuvwxyz abcdefgh
ijklmnopqrstuvwxy

Variations 4. For CONCAVE LET- TERS, use O as a prototype. Open and one-stroke letters do not have concave main strokes. For CONVEX LETTERS make the serif part of the main stroke.

abcdefghijklmnopqr
stuvwxyz abcdefghij
klmnopqrstuvwxyz

Variation 5. Try two BOLD Gothic styles, one concave, one convex.

abcdefghijklmno
pqrst u vwxyz

Variation 6. Touch up Gothic serifs with a smaller pen.

PEN ANGLES: *Variation 4 45°; Variation 6 45°*

PEN ANGLE: *Variation 5 + 4 45°*

abcdefghijklm
nopqrstuvwxyz

The basic Book- hand alpha- bet, reviewed on pages 42~45.

abcdefghijklmnop
qrstuvwxyz. -

Variation 1. A steep PEN ANGLE plus a flame-shaped serif give Bookhand a Middle Eastern flavor.

abcdefghijklm
nopqrstuvwxyz

Variation 2. A SLANTED Bookhand has important differences from Italic.

abcdefghijklmn
opqrstuvwxyz

Variation 4. Squared- off Bookhand harmonizes with Roman. (page 56, variation 4)

PEN ANGLES: *Bookhand 20°, 45°; Variation 1 85°; Variation 2 20°, 45°; Variation 4 20°, 45°.*

abcdefghijklmno
pqrstuvwxyz

Variation 5. A BOLD Bookhand.

abcdefghijklm
nopqrstuvwxyz

Variation 5. The gracefulness of Bookhand becomes more visible when you make it LIGHTER. Use Chiz'l felt pen, fountain pen with B2 nib, Mitchell pen with #3 nib, quill cut to ⅛".

abcdefghijklm
nopqrstuvwxyz

Variation 6. Emphatic but not elegant, Bookhand with shortened ASCENDERS and DESCENDERS and heavy one-stroke SERIFS.

abcdefghijklm
nopqrstuvwxyz

Variation 6. A useful and beautiful style, Bookhand with lengthened ASCENDERS and DESCENDERS and hair-line SERIFS.

PEN ANGLE: *Variation 5 (bold) 20°, 45.°*

PEN ANGLES: *Variation 5 (light) 20°, 45°; Variation 6 20°, 45°; Variation 6 20°*

abcdefghijklmn
opqrstuvwxyz
The basic Italic alphabet, reviewed on pages 46~49.

abcdefghijklmn
opqrstuvwxyz
Variation 1. A flat PEN ANGLE.

abcdefghijklmn
opqrstuvwxyz
Variation 2. An UNSLANTED Italic harmonizes with many other styles.

abcdefghijklmnopqrstu
abcdefghijk
Variation 3. Italic can be NARROWED or WIDENED.

PEN ANGLES: Italic 45°; Variation 1 10°; Variation 2 45°; Variation 3 45°.

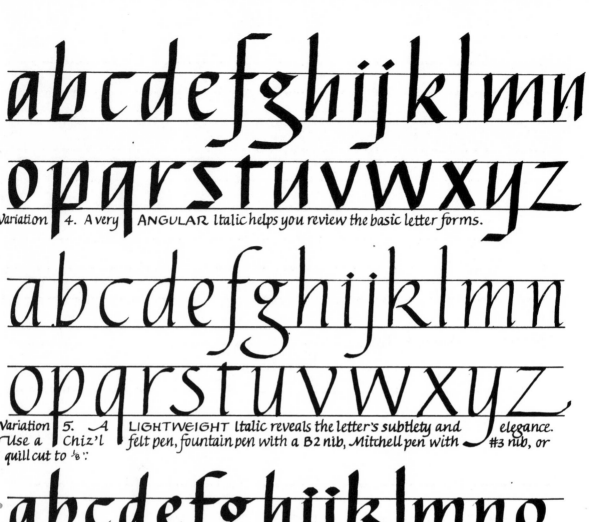

abcdefghijklmn
opqrstuvwxyz

Variation 4. A very ANGULAR Italic helps you review the basic letter forms.

abcdefghijklmn
opqrstuvwxyz

Variation 5. A LIGHTWEIGHT Italic reveals the letter's subtlety and elegance.
Use a Chiz'l felt pen, fountain pen with a B2 nib, Mitchell pen with #3 nib, or
quill cut to ⅛″.

abcdefghijklmno
pqrs stuvwxyz

Varia-tion 5. A BOLD Italic is emphatic and appealing, but the beauty of
the joins is lost.

abcdefghijklmn
opqrstuvwxyz

Variation 6. To de- velop the Italic SERIF, choose from a range of SWASHES.

PEN ANGLE: *Variation 5 (bold) 45°.*

PEN ANGLES: *Variation 4 45°; Variation 5 (light) 45°; Variation 6 45°.*

Continue your exploration of alphabet variations by using both your hand and your eye. When a calligraphy project calls for a visual accent, try one letter, one word, or one line of a varied alphabet for emphasis. Build up your repertoire gradually.

While you practice what you know, be alert to alphabet variations when you see them around you. Billboards, advertisements, book jackets, and letter-heads often contain innovative letters. Practice active seeing. Take letters apart visually when you see a new style or when a teacher or a book presents it to you. Which major historical style is it derived from? What kind of pen shaped it, with what pen angle, letter angle, letter width, and letter height? Look at the ascenders and descenders, and the serifs. Look at the spacing.

Don't be thrown off by the names of styles. Many overlapping classification systems exist; the list below covers most of the common ones.

ROMAN	CELTIC	Gothic	Italic	Bookhand
Trajan	Uncial	Blackletter	Chancery	Foundational
Capitals	Half-uncial	Old English	Current	Humanistic
Classical	Irish	Fraktur	Cursive	
Quadrata	Insular	Textura	Chancellaresca	
Rustica		Rotunda		
		Batarde		

III

Everyday Calligraphy Projects

Success in your work, the finding of a better method, the better understanding that insures the better performing, is hat and coat, food and wine, is fire and horse and health and holiday.

Ralph Waldo Emerson

Remember that NOTHING would get done at all if a person waited until he could do it so well that no one could find fault with it.

Anonymous

A FAVORITE QUOTE, MATTED AND FRAMED

More than any other project described in this section, the handlettered quote is the calligrapher's special province. Technology and the growth of related letter arts have encroached on the calligrapher's traditional world, offering non-calligraphic ways to copy books, write correspondence, address envelopes, draw up contracts, and store and display information. There remains, however, only one way to make just one copy of a quotation — economical, readable, appealing, and permanent — and that is handlettering.

A handlettered quote differs from simple copying in that the information contained in the text is not the sole message in the finished piece of calligraphy. The design should have a visual message all its own — partly in its harmony or contrast with the meaning of the text, but also within itself, through its proportion, texture, letterstyle, layout, materials, and color.

Since quotes are your stock in trade, practice a creative and orderly approach to their collection and selection. When you see an interesting quote, WRITE IT DOWN. Don't worry about neatness; but don't rely on your memory and don't forget the author's name. Recopy it neatly in a book or onto file cards. Some calligraphers like the "neutrality" of a typed card; no particular calligraphic design is preordained when the time comes to pull it out and letter it. Look for the odd, intriguing, little-noticed quote. Select it, polish it, and

set it in the light, and you have done an artist's job.

Some texts seem to dictate their own treatment; a German Christmas carol in Gothic, an Irish prayer in Celtic, a sonnet in Italic. Others are less obvious, requiring the calligrapher to set the tone. Consider the wealth of alternatives, especially when the text is familiar enough to sustain a viewer's interest in an unusual, challenging layout.

Try some of your favorite quotes more than once. You may have more original ideas lurking behind your first design.

Nearly everyone has a favorite quote, or knows some one who has. Some of your work will come from these commissions, where people ask you to do a piece of calligraphy on their text, either to keep for themselves or for them to give as a gift.

The calligraphy you do for yourself will differ from what you do for other people. You can experiment more with unusual, abstract, startling designs. Many people who commission a favorite quote, however, will not understand this kind of design and will prefer one simpler and

Contrast conventional and unconventional treatments of the same quote. Often the quote you choose yourself will be more unusual and thus suggest an unusual design.

more conventional. Calligraphy that you do for yourself can be a work of art like a poem or a painting. Calligraphy done to order, on the other hand, is generally more like a piece of journalism or a portrait; the essential thing is to get the message across, not to call attention to the art. Keep in mind the tastes and expectations of the ultimate recipient.

To get ideas for your calligraphy designs and commissions, look around — not just at other calligraphers' work but at any visual art that has techniques and effects related to calligraphy. The intricate patterns of a Fair Isle sweater might encourage you to try using different colored letters in each row to form an overall design. Elegant, unusual typefaces and book cover designs can lead you to more precision. Etched motifs on glassware can suggest subtly transparent, overlapping letters. A landscape photograph can inspire you to experiment with letters to give the same illusion of depth. And illuminations of medieval manuscripts can influence you, not to make your own work look medieval, but to incorporate into it the same rich contemporary feeling that these manuscripts reflected about their own time. Copy technique and ideas, not designs.

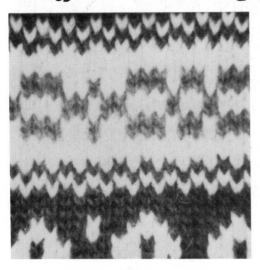

to

every thing there is a season, and a time to every purpose under the heaven; a time to be born, and a time to die; a time to plant, and a time to pluck up that which is planted; a time to kill, and a time to heal; a time to break down, and a time to build up; a time to weep, & a time to laugh; a time to mourn and a time to dance; a time to cast away stones, & a time to gather stones together; a time to embrace, and a time to refrain from embracing a time to seek, and a time to lose; a time to keep, and a time to cast away; a time to rend, and a time to sew; a time to keep silence, and a time to speak; a time to love, & a time to hate; a time of war, & a time of peace.

Knitted patterns

Vivaldi BANQUET

Type and handlettering

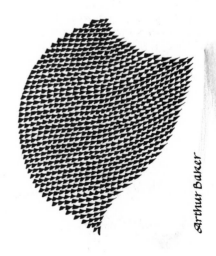

I
once
came across
an early book
about navigation
of the air, published
in the 18th century, & was
enchanted by a suggestion
the author made for the in-
vention of airships. The idea was
that people should go to the tops of
high mountains and there collect the
fine, pure, light, rarefied air of the
summits, & put it into the bags;
and seal the bags, and bring
them down to the
common level
of every
day
the upward
lift of those
bags to a raft.
they can be
used as an
airship.

And
there,
by at-
-taching

THAT
IS WHAT
LOVERS OF
FINE BOOKS
FIND IN THE BOOKS
THAT THEY LOVE —
THE LIGHTER AIR OF THE
MOUNTAIN PEAKS OF HUMAN LIFE.

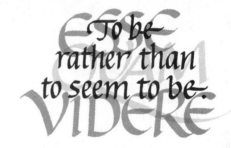

To be
rather than
to seem to be.

ESSE QUAM VIDERE

Landscape

Transparency

Arthur Baker

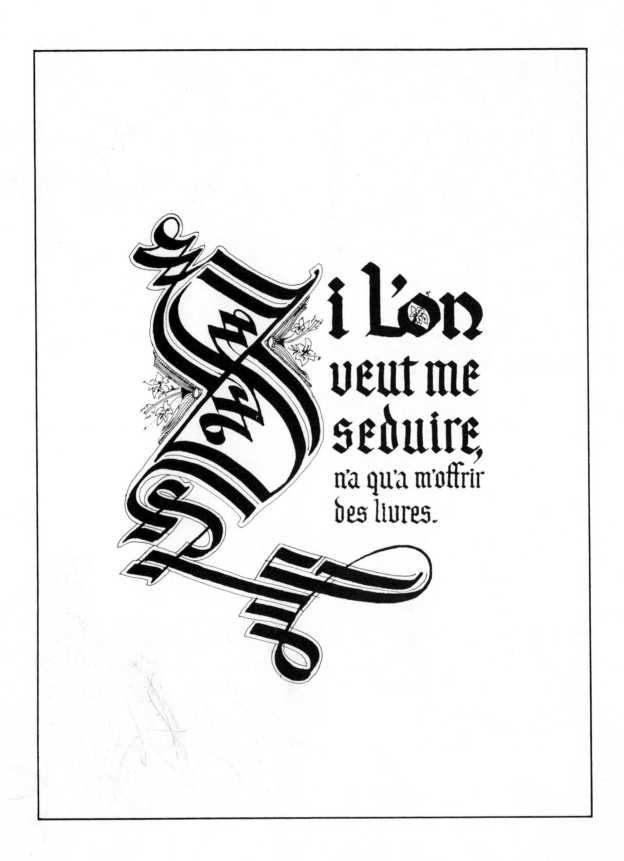

i l'on veut me seduire, n'a qu'a m'offrir des livres.

John I never had a hat, never wore one, but recently was given a brown suede O duck-hunting hat. The moment O I put it on, I realized I was starved for a hat. I kept it warm by putting it on my head. I made O plans to wear it especially when I was going to do any O O thinking. Somewhere in Virginia, I lost my hat. O cage

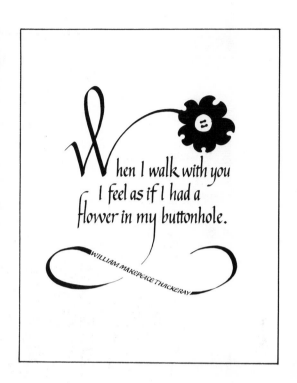

When I walk with you I feel as if I had a flower in my buttonhole.
WILLIAM MAKEPEACE THACKERAY

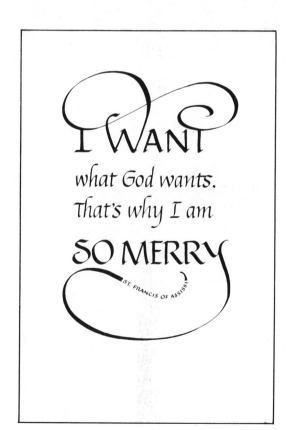

I WANT
what God wants.
That's why I am
SO MERRY
ST. FRANCIS OF ASSISSI

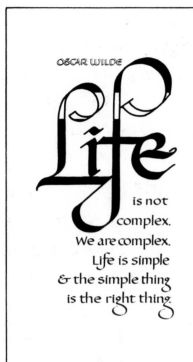

OSCAR WILDE

Life is not complex. We are complex. Life is simple & the simple thing is the right thing.

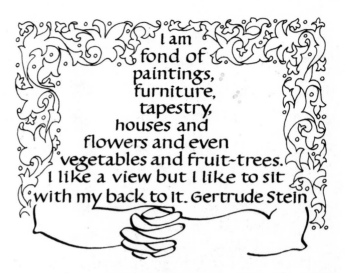

I am fond of paintings, furniture, tapestry, houses and flowers and even vegetables and fruit-trees. I like a view but I like to sit with my back to it. Gertrude Stein

I am always content with that which happens; for I think that what God chooses is better than what I choose.

EPICTETUS

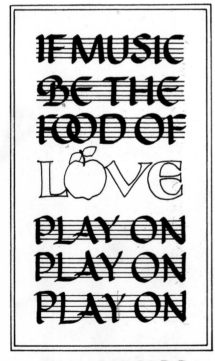

IF MUSIC BE THE FOOD OF LOVE PLAY ON PLAY ON PLAY ON

SHAKESPEARE

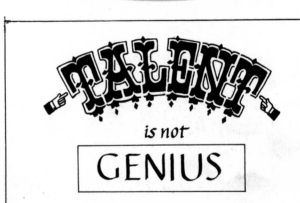

TALENT is not GENIUS & wishing won't make it so.

Louisa May Alcott

Matting and framing a piece of calligraphy serves two purposes: protecting it physically from bending, abrasion, and moisture, and enhancing its appeal visually. Mats, like calligraphy, have color, texture, scale, and proportion. They can harmonize with the calligraphy or compete with it.

First, choose a conservative color of mat. It should exactly match one of the colors already present in the letters or ornament, preferably not the main color. If the piece is black and white, you can choose gray, cream, or any color that contrasts with the paper. A very delicate piece can be enhanced by a few lines or bands of soft color along the edge of the mat opening ("French mat" technique).

Next, examine the mat's texture and compare it with the "texture" of the calligraphy. Don't let one overpower the other.

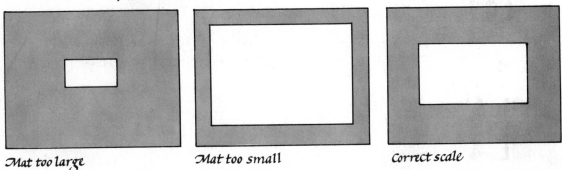

Mat too large Mat too small Correct scale

Scale refers to the size of the mat opening in relation to the size of the mat itself. The scale should not make the calligraphy look puny or overbearing.

Finally, proportion is the simplest part of designing a mat. 99 out of 100 mats should conform to the general models shown here:

Top and side margins are equal, with bottom margin about one fourth larger.

The basis for these proportions lies with the layout of the traditional book page and document of the Western world for the last 2000 years. People usually read

books by holding them at the bottom edge and turning the pages from the top corner. Large letters are concentrated at the top. Documents often have a large space for signatures at the bottom.

In contrast, calligraphy in the Oriental tradition is usually "matted" into scrolls. People read them by holding them from the top and taking up the slack below. Scrolls hung on the wall put the text down low at eye level.

In both cases, the extra white space that

evolved out of the need to keep the text free of fingers and fingerprints has established itself as the correct traditional way to proportion a page of calligraphy and the space around it.

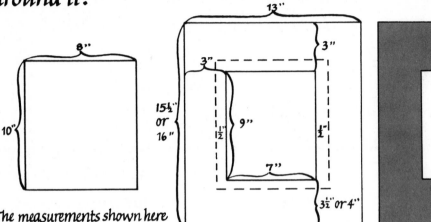

The measurements shown here are proportioned for an 8" x 10" piece of calligraphy. Use the same general ratios with other sizes. Be sure you allow for that ½" on all four sides when you design the piece. It's easy to remove it but mighty hard to add it on.

Mats can be bought precut and assembled, or made to order at a framing studio. To custom-make a mat yourself, first measure your calligraphy and compute the size and kind of mat board you need. Draw the measurements and guidelines lightly with pencil; erase after cutting.

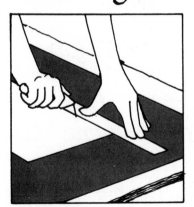

Cut the mat by holding a cork-backed metal ruler down HARD and cutting along it slowly with a heavy-handle mat knife. Pad the mat board with 20 layers of newspaper. Be very, very careful not to let your fingers stick out over the edge of the ruler and get cut.

Hold the knife blade upright against the straightedge. Later, when you have more experience, you can try angling it a little to produce a beveled cut.

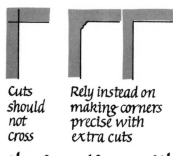

Cuts
should
not
cross

Rely instead on
making corners
precise with
extra cuts

Be finicky about the four corners of the mat opening. Don't let the cuts cross each other even slightly. It's better to let them fall a little short, leave the corner a little ragged, and sharpen up the junction with a second cut.

Fasten the mat to its backing with a hinge of masking tape across the top, so that they open like the covers of a book. Attach the calligraphy to the backing (first position it visually with the mat nearly closed) with two pieces of paper gummed with library paste, or special linen tape.

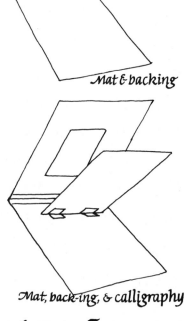

Mat & backing

Mat, backing, & calligraphy

Now you have to protect the surface with some degree of permanence. At the very least, slip a sheet of acetate the same size as the piece of calligraphy in between the calligraphy and the mat. You can wrap the whole mat in acetate, allowing about 3" of overlap to fasten in back with masking tape. For more permanence, have it professionally "shrink-wrapped." Or finally, put mat and calligraphy into a frame.

Choose your frame on the basis of your expertise. If you have the tools and skills to make wooden frames, or know someone who does, you can give your

calligraphy first-class treatment. Even without woodworking, however, you can do some quite beautiful and inexpensive framing with secondhand frames collected from antique stores, yard sales, and flea markets. Take the dustproof paper off the back, pull out the nails, remove the stiffener, backing, picture, and mat, and lift out and clean the glass. Notice how everything fits together. Then put everything back, replacing any worn out or missing ingredients. Often these recycled frames contribute a fine and gentle look to your calligraphy that a new frame just wouldn't have.

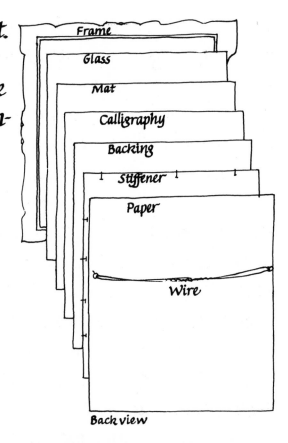

Back view

Paper's greatest enemy is sulphur, both in the air and in other papers. Help your calligraphy live a long, unyellowed life by taking the following precautions: Letter finished pieces only on 100% rag paper, use 'museum board' for mat, backing, and stiffener, and paste dust-proof paper on the back of the framed piece. Also, treat the piece to an hospitable climate: do not hang it near a heating vent, in a moldy cellar, or under direct sunlight.

A frame with a very sleek, contemporary look can be put together with precut metal pieces that join at the corners with a screwdriver.

Slide two corners (three sides) together and tighten screws. Insert glass, mat, calligraphy, backing, and stiffener; add 4th side & tighten.

Back view

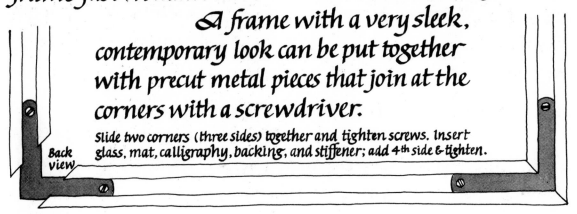

Another kind of frame is characterized by a moveable fourth edge that allows you to slide out the glass and stiffener and insert the calligraphy.

Front view

Back view

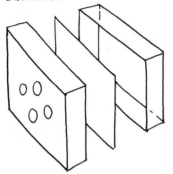

The finger-holes in the smaller box are also used for hanging. Don't insert the box backwards!

A further simplification of frame construction unites the functions of glass and frame in a thick plastic box. The mat and calligraphy are held against the plastic by a smaller box that fits tightly inside the plastic box. and unites the functions of stiffener, nails, and hanger.

Two products exist which enable the calligrapher to eliminate the frame almost altogether. Sandwich the calligraphy between two layers of glass or one each of glass and backing, and hold this sandwich together

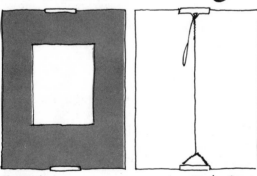
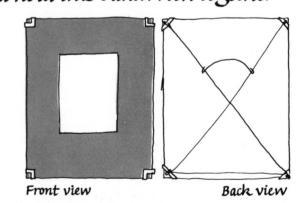

Front view Back view Front view Back view

with clips at top and bottom or all four corners.

Balance all these concerns — deadlines, costs. your skills, and the importance of the calligraphy itself— when you make a decision about frames.

ARTWORK REPRODUCED *for an* ANNOUNCEMENT

Sooner or later, unless you practice calligraphy at the bottom of a well, some one is bound to ask you to design an announcement to publicize an event, a product, or a service. Your first client could very well be yourself, in need of a simple brochure to give away that describes your calligraphy. Or you may be able to help out an organization you belong to.

Whatever the project, if you are doing calligraphy for reproduction you need to know a little about commercial art, and if you are dealing with a printer you need to speak the language of the printer's art.

 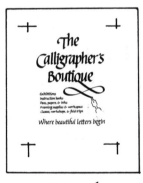

Typewritten copy Idea Rough draft Printed pieces

Artwork

The calligrapher takes ordinary typed or handwritten text ("copy") and organizes it into an attractive, eye-catching design. From the original idea — a small sketch or a design in your mind's eye — a detailed full-size rough draft (a comprehensive layout or "comp") is drawn up, corrected, and approved. Then the calligrapher letters a black-and-white original ("camera ready artwork"). The printer makes a photographic negative from this artwork, makes a thin plate

(about as heavy as the cover of this book) from the negative, and prints copies from the plate through the intermediate step of a rubber pad, onto paper. (If you're interested in learning about printing, your very first research should be a trip to your local printery or copy center to see how the process works. Read up on it afterwards.) This process is called "photo-offset," "offset," "offset lithography," etc., and is the most common technique for medium-sized jobs like your announcement.

 The first step in producing a printed piece is to type and EDIT the copy. Don't wait until you have 500 copies to notice that the date is wrong. Check the copy carefully.

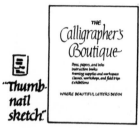

"Thumb-nail sketch"

Trace the good parts of a design when you rework one detail. Don't start from scratch each time.

 Next, sketch your idea as simply as possible. An announcement should grab your attention with a strong graphic idea. The subtlety, finesse, and detailed craftsmanship that make a handlettered quote so satisfying to live with are often wasted on an announcement, while the blatant, straightforward and utilitarian design that makes an announcement effective can push the quote into nerve-jangling obviousness. It's hard to be simple; your nuts-and-bolts calligraphic announcement, like a two-page book report or a five-minute after-dinner speech, is usually the result of a good deal of discipline and patience.

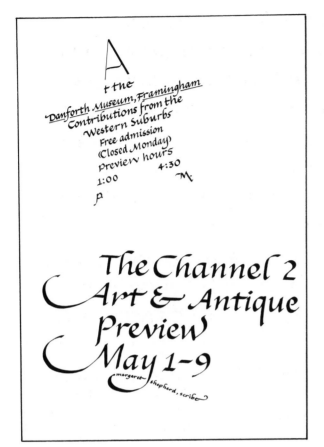

A
t the
Danforth Museum, Framingham
Contributions from the
Western Suburbs
Free admission
(Closed Monday)
Preview hours
1:00 4:30
p M.

The Channel 2
Art & Antique
Preview
May 1-9
margaret shepherd, scribe

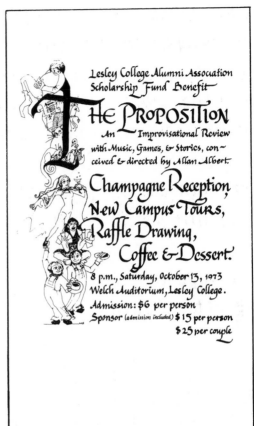

Lesley College Alumni Association
Scholarship Fund Benefit
THE PROPOSITION
An Improvisational Review
with Music, Games, & Stories, con~
ceived & directed by Allan Albert.
Champagne Reception,
New Campus Tours,
Raffle Drawing,
Coffee & Dessert.
8 p.m., Saturday, October 13, 1973
Welch Auditorium, Lesley College.
Admission: $6 per person
Sponsor (admission included) $15 per person
$25 per couple

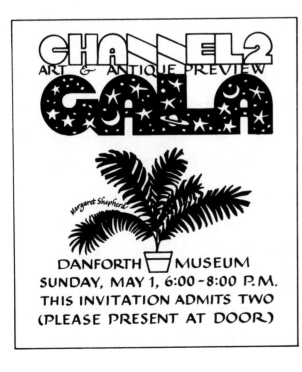

CHANNEL 2
ART & ANTIQUE PREVIEW
GALA
Margaret Shepherd
DANFORTH MUSEUM
SUNDAY, MAY 1, 6:00 - 8:00 P.M.
THIS INVITATION ADMITS TWO
(PLEASE PRESENT AT DOOR)

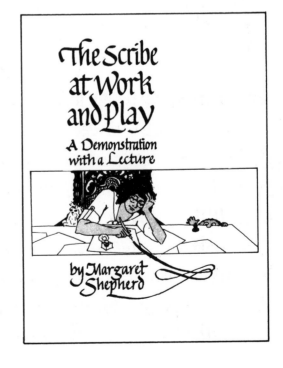

The Scribe
at Work
and Play
A Demonstration
with a Lecture

by Margaret
Shepherd

Outline photo area and sketch subject.

Show large headlines in place.

Indicate small letters with parallel lines.

Make comp same size as finished piece to help visualize final effect.

The goal of this initial process of pencilling and erasing, tracing and retracing, is to emerge at the end with a comp that shows in rough form how the finished announcement will look. Letter the headlines, block in lines of smaller letters, outline photographs and drawings. If you plan to use colored paper, get a sample from your printer to ascertain exact color and availability; if you plan to use colored ink, come as close as you can with colored calligraphy felt pens. Your comp should give the overall EFFECT of the finished piece without the fine quality of EXECUTION.

Shown here is the next step—artwork. Some artists work on "illustration board," a smooth paper mounted on a thick, stiff backing. Calligraphers may, however, prefer to work on one of the stiffer calligraphy papers and paste it onto illustration board if any more stiffness is needed.

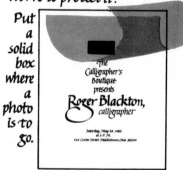

Tape tracing paper over artwork to protect it.

Put a solid box where a photo is to go.

These marks show where the edge of the page should be.

Artwork may be done extra-large (1¼ to 1¾ times) and reduced for sharpness.

Your artwork, to be camera-ready, must be in sharp black and white. Use black ink only. If you want a letter to be green, don't do it in green ink; do it in black ink and designate it as green in the margin. The printer must make a separate plate and do a separate press run for each color.

The printer's camera sees only all-black or all-white. Gray areas, paintings, and photographs must be

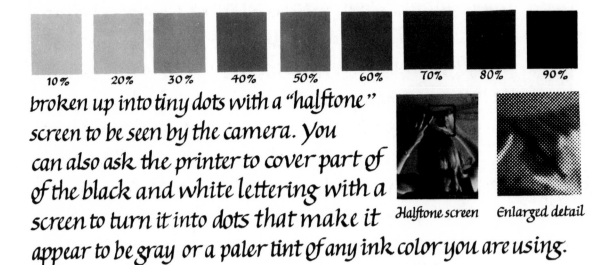

| 10% | 20% | 30% | 40% | 50% | 60% | 70% | 80% | 90% |

broken up into tiny dots with a "halftone" screen to be seen by the camera. You can also ask the printer to cover part of of the black and white lettering with a screen to turn it into dots that make it appear to be gray or a paler tint of any ink color you are using.

Halftone screen Enlarged detail

BLACK
RED
BLUE
WHITE

What your eye sees

BLACK
RED

What the camera sees

 Remember that the camera is filtered to photograph red as though it were black, and blue as though it were white. Notes and guidelines on the artwork itself should be written in a special "non-repro blue" pencil.

 Because of this high-contrast feature of the photo-offset camera, the surface of your calligraphy does not have to have the same perfection demanded from a one-of-a-kind piece of calligraphy. Corrections are simplified; either paint white over the error and reletter, or paste in a piece of paper with the correction lettered on it.

 When the artwork is finished, try to have someone else check it over. Make a Xerox copy and do a kind of

"dry run" for its ultimate purpose; tack it on a
bulletin board and look at it from a distance,
fold it and mail it, display it on an exhibit
table, hand it out on a street corner.

An announcement, in
its native habitat.

After you've gotten the bugs
out, take the artwork to the printer. Have the following infor-
mation worked out, agreed on, and WRITTEN DOWN to
avoid delay or mistakes on your job.

JOB TICKET FOR PRINTING CALLIGRAPHY

Description _____

Size _____ Quantity _____

Ink color(s) 1. _____ 2. _____

Paper description _____ Color _____

Photograph or other halftone _____

Folds, staples, etc. _____

Special instructions _____

Date needed _____

Printer's estimated cost _____

BILL TO SHIP TO

Name _____ Name _____

Address _____ Address _____

Telephone _____ ☐ HOLD FOR PICKUP

DESIGNING A LOGO, LETTERHEAD, & CARDS

Why not start with yourself and design an emblem for your own calligraphy? Whether it's a space cleared on the kitchen table or a full-fledged room of your own solely for lettering, your "studio" can be a reality in the minds of others.

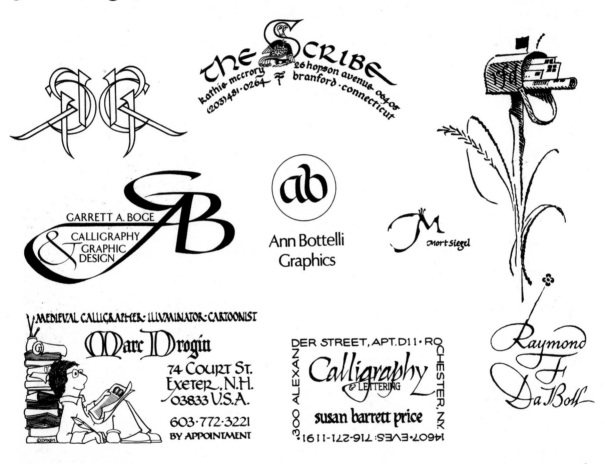

Sum it up with a logo that symbolizes your individual approach to calligraphy. Some professional calligraphers' logos are shown here as an inspiration to get you started experimenting with your own ideas. In this, as in your other creative work, avoid copying. Calligraphy abounds with symbols — quills,

Realistic Pen-drawn Scripted

Abstract Calligraphy by margaret shepherd Animated

pen points, inkpots, letter shapes, alphabets — and with
distinctive historical styles to render them in; you have a
wealth of material to work with when you create your logo.

Designing your own logo is good practice
for the time when you are called upon to design one for some-
one else. Here your job is harder. You have many questions to
ask and to answer. What are the familiar symbols of this field?
Is this company or person likely to change and outgrow the logo?

One specialized, one general, logo.

A music synthesizer manufacturer, for
instance, will be limited by a keyboard
logo if they begin to make guitars or foot
pedals. A logo that symbolizes the ab-
stract concepts of music and electronics
will be more usable.

By the same token, a landscape architect
is unlikely to outgrow a plant motif; a
needlepoint supplier's name insures the relevance of a sheep; and
a singing group will always use notes (top row, next page).

Woolcraft, Inc.

NORTH STREET MEDFIELD, MA 02052

L. JAMES GLINOS Associates

Frank William Sellner

Consulting Landscape Architect, A.S.L.A.

youth pro Musica

YPM

mary mcdermott shideler

BOULDER HEIGHTS, JAMESTOWN STAR ROUTE, BOULDER, COLORADO 80302

303=449-5071

With your basic idea settled, evaluate it for its versatility in terms of size and scale. Will it be attractive and easy to understand in a variety of uses and sizes? How will it look on a billboard? a T-shirt? a matchbook cover? A logo

Corporate identity strikes again!

that looks romantically ornate on a letterhead may fade into cobwebby insignificance when reduced to fit onto a standard business card. And a bold little design that jumps off a business card so assertively can be pretty scary jumping off a sign. Aim for a safe, usable middle ground.

Designing a logo is not perhaps as complicated a process as all these precautions might suggest. Sometimes the idea just slides into existence fully grown, and the letters organize themselves into a design. You can cultivate this fluency by constant use of your eyes. Study every logo that comes your way. While most logos are designed by commercial graphic artists, not

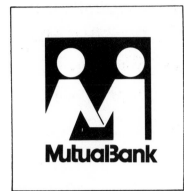

Mutual Bank

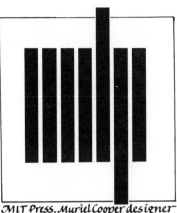

MIT Press, Muriel Cooper designer

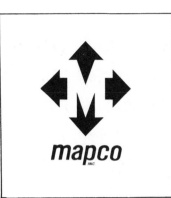

Mapco

Prime Computer

GF Office Furniture Systems

J.J. Case Co.

Sack Cinemas

Zildjian Cymbals

Mutron, courtesy ARP Instruments

calligraphers, still you can learn many interesting things about
letters from their designs. How does the Case logo relate to what
you know about Gothic? Compare the MIT Press logo to the
first Gothic variation (page 62) or the Zildjian logo to the
last Celtic variation (page 60). Mutron, Mapco, and GF
show ingenious use of positive and negative space.

Letter your logo design very carefully in sharp black and white, at least 1½ times size for clarity of detail. Then, before you do anything else, get photostats (black and white copies) made in different sizes — and put the original artwork away in a safe place.

Now evaluate your or your client's stationery needs. A little realistic planning at this point can save you a lot of trouble and expense later on.

First, what items are needed? Not things that you'd like one or two of occasionally, but things you'll use lots of, day in and day out. Most probably your list will start with these: LETTERHEAD, ENVELOPES to fit a folded sheet of letterhead, and BUSINESS CARDS. That's all. Later on you may find yourself in need of MAILING LABELS and a short BROCHURE describing your services. Resist the impulse to print up specialized, expensive things like invoices, statements, large mailing envelopes. Instead, buy a RUBBER STAMP custom-made from your logo and use it to personalize these stock items bought from

Letterhead

Envelope

Business card Essentials

A New Calligraphy Service
INVITATIONS: card design, envelope addressing, place cards, and seating charts.
DIPLOMAS: quick, accurate engrossing, decorative scrolls and citations.
ARTWORK: design & execution of brochures & flyers
INK, INC. 272-0211

Brochure

Mailing label Options

Stock stationery items, personalized with a rubber stamp.

a stationery store in small quantities.

Second, how many are needed of each thing? Plan for a two-year supply of the essentials unless some special circumstances indicate a longer or shorter life span. Xerox a few copies of your brochure for a few months' dry run; better an inexpensive copy of your most up-to-date talents than a costly printing job showing your level of expertise two years ago. Handletter or rubber stamp your mailing labels until you need a lot of them. Rubber stamp your logo onto invoices and statements until you need more than 200 per year; then you can have them printed up more economically than you can buy them.

With list in hand, check with your printer before you do final artwork. Make sure: the paper you've set your heart on doesn't require a three-month delay; the envelopes to fit an odd-size sheet haven't been discontinued; and your specially mixed ink doesn't cost more than all else combined.

Now prepare the artwork. Choose a basic format: centered and formal, off-center and informal, or vertical and contemporary. Remember that you are designing a letter, not an empty sheet of letterhead; try to visualize the final effect the stationery will have when it is opened,

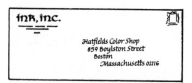

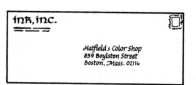

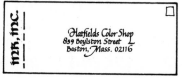

Formal, centered layout Informal, asymmetrical layout Bold, contemporary layout

unfolded, and read by your correspondent. If you have trouble
imagining the finished product, run some Xerox copies of the
artwork and experiment with them; try both typing for real
business letters, and hand lettering for the communication
most people expect from a calligrapher.

ROOTS: TWO DESIGNS FOR A FAMILY TREE
AND TWO WAYS TO ORGANIZE GENEOLOGICAL INFORMATION

Tracing your family's history takes several steps. First assemble all the oral history you can squeeze out of your relatives. Try to pin down birthdates, birthplaces, photographs, maiden names, and interesting stories. Don't overlook distant cousins who can shed light on that great-great-grandparent you have in common.

Check your material through geneological societies, church registers, family bibles, old newspapers, and tombstones. Make a final draft of only your firmly documented facts, but keep your notes for further research.

Now evaluate your final draft, and ask yourself some questions about its strengths and weaknesses. Do you have a notable ancestor whose descendents (including you) are all known and would be interested in a family tree that

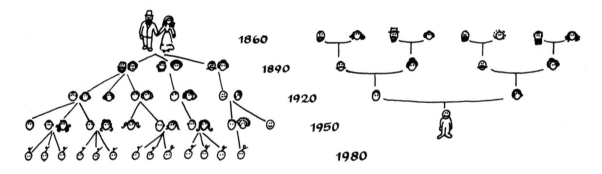

showed them? Or does your information show several generations reaching back, perhaps on both sides, to "the old country"— the point at which they emigrated to America?

Your first decision must be whether your family tree will focus on DESCENDENTS or on ANCESTORS. There are two important differences in approach. The layout for the ancestors puts the numerous ancestors on the left. The layout for the descendents puts the numerous descendents on the right. The second difference is in symmetry — while a person has two parents, he may have any number of children or none at all. Thus, the ancestors approach will look pretty much the same for everyone; each descendents approach will be unique.

In either case, start your layout at the numerous side, spacing the first row of people out evenly. Starting anywhere else will give you the profoundest spacing

An ancestor's family tree

problems. You may want to leave extra space at left on an ancestors chart (above) in case more research turns up more ancestors, & at right on a descendents chart (opposite page) to accommodate additions when more children are born. The large blank areas top and bottom are ideal for photographs,

A descendents family tree

Add visual interest to your family tree with photographs, drawings, maps, and heraldry.

heraldry, or illustrations.

A few ground rules will help you prevent chaos in organizing your family tree layout. With the ancestors approach, if you have only a few names in some generations leave space for the missing names. Otherwise it will throw all the spacing off. Put the husband or wife's name first and then stick to that order. For the descendents approach, indicate the difference between a blood relation and a spouse who has married in, by a different size or style of letter. Remember to leave space for a marriage date. Be particularly vigilant against errors; spelling mistakes (even of your own name!) have an inordinate fondness for creeping into family trees.

An ancestors family tree

Now, change your whole orientation from left-to-right to up-and-down. If you curve the lines to fit in the numerous ancestors, you can transform an ordinary chart into something quite special—a real tree. Use a compass for the outer rings of ancestors, and a pencil (and a lot of

erasing and repencilling) for the interior branches of more recent ancestors. If you want a simpler layout, do all the generations in concentric rings and just draw the branches in as real branches.

As with the chart layouts, you can have the tree show

A simplified tree layout

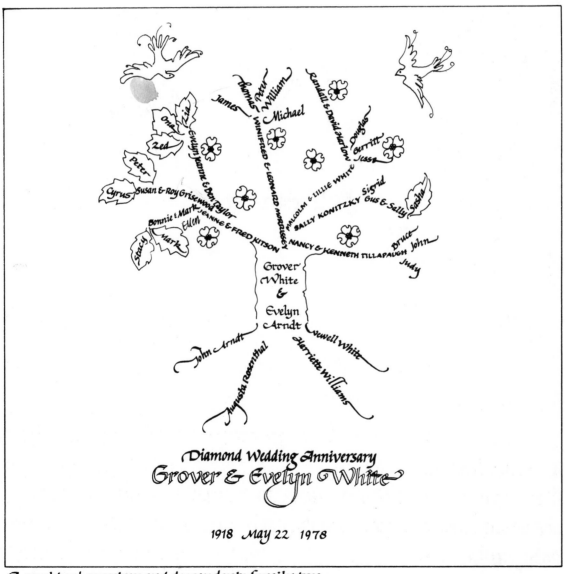

A combined ancestors and descendents family tree

ancestors (page 106) or descendents (page 107). If you have an interesting grandparent, a geneological tree with both roots and branches makes an appealing display. Make one poster-size tree, have your printer reduce it and print copies, and you have the ideal gift for a 50th wedding anniversary or large family reunion. Color in the original and display it.

Family trees make a lovely gift to a new-born child. You don't have to do a lot of research; give a mostly blank pencil layout, with baby's and parents' names inked in lavishly. A family tree in abbreviated form makes a unique birth announcement, showing the new sprout.

Researching your roots gives you a sense of belonging, a feeling of continuity with the past. There is no

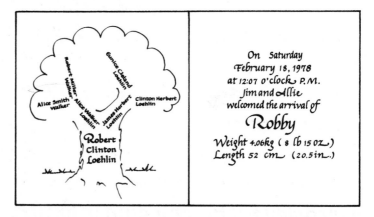

On Saturday
February 18, 1978
at 12:07 o'clock P.M.
Jim and Allie
welcomed the arrival of
Robby
Weight 4.06kg (8 lb 15 oz.)
Length 52 cm (20.5 in.)

Karin
Lanahan Larsen
was born on
July 23, 1979
at 3 o'clock A.M.
9 lb. 2 oz
20 in.

Two family-tree baby announcements.

better way to present your family tree than with a graceful, well-planned layout, simple ornamentation, and traditional calligraphy.

PARTY GRAPHICS: INVITATIONS & SEATING

Calligraphy adds a uniquely festive note to a party, whether you are giving a dinner for six or a wedding for 600. You make people feel that the event is something very special if you have invited, greeted, and seated them with beautiful letters. It is well worth the extra planning.

The steps detailed in this chapter apply to a medium-sized wedding with a sit-down dinner, because that kind of party includes all the different handlettered items you need on a smaller scale for smaller parties. Just reduce or omit whatever doesn't seem appropriate for a small wedding, a wedding with a stand-up reception, an anniversary celebration, a bar mitzvah, a buffet supper, a a birthday party, or a dinner for six.

To begin your plans you need an event, a place, a time, a general theme, and a list of guests. You also need a BARE MINIMUM of six weeks.* Type up a guest list with one column per page. (You will need the extra space later on.) Count the names, take a deep breath, and add 50% to the total for last minute additions. Don't skimp; it's much better to spend a few pennies for extra copies than to spend a lot of dollars to print those extra copies later. Avoid the delay, chagrin, and extra expense.

* If you get started late, and still want to send printed invitations, get on the telephone to invite everyone verbally. Then the invitations can come late, near the party date, as a confirmation, and no one's plans will be spoilt.

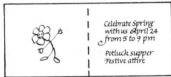

An informal self-mailer, printed or Xeroxed onto 8½ × 11 colored paper, folded, sealed, and hand-addressed.

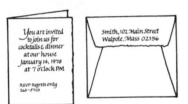

A semi-formal printed invitation and envelope.

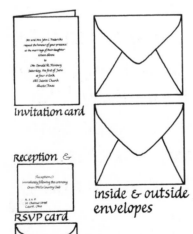

Invitation card

Reception &

RSVP card

inside & outside envelopes

RSVP envelope

Formal invitation with enclosures.

Now decide how to REPRODUCE the invitation. If you have less than a dozen to send out, consider handlettering each one, either starting from scratch or filling in blanks on a preprinted card. If you have more than a dozen, you should handletter one black-and-white original and get it reproduced by xerox or photo-offset.

Next, find out what is available in PAPER and ink colors. Browse the shelves of a stationery store for cards and envelopes. Don't be surprised if it is cheaper and simpler to buy them there than at your printer's; paper companies are reluctant to sell quantities of less than 100 sheets of paper and 500 envelopes, and will probably charge extra to handle the smaller quantities.

Once you have decided on paper and ink look objectively at your WORDING. For correct formal usage, consult an etiquette book; don't risk getting it <u>almost</u> right. If you depart from conventional wording, proceed with great caution to avoid awkwardness and verbosity. Be sure to suit the tone to the tone of the party

to clue your guests in beforehand about what to expect and how to dress.

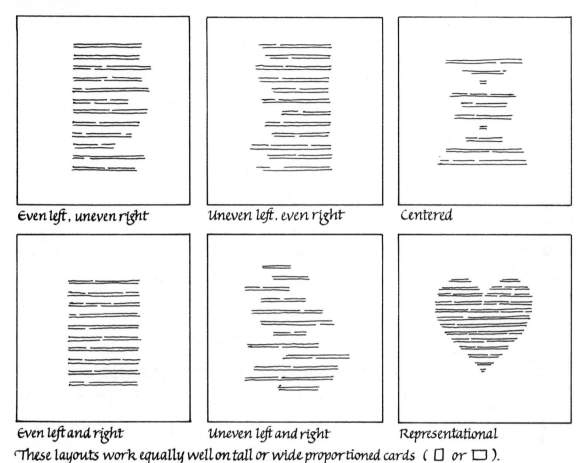

Even left, uneven right Uneven left, even right Centered

Even left and right Uneven left and right Representational

These layouts work equally well on tall or wide proportioned cards (☐ or ▭).

 With your paper and wording firmly decided on, DESIGN the invitation. Review the six main types of calligraphic layouts and choose the one that best suggests the mood of the party. Suit layout to wording in tone as well as shape. The more formal the occasion, the less your wording and layout should differ from conventional models. The less formal the party, the more inventive the calligraphy can be. The next page shows a few designs from the wide range of creative possibilities.

soon may there be heard
the voice of joy & gladness,
the voice of the bridegroom
and the voice of the bride,
the jubilant voices of those joined in
marriage under the bridal canopy,
and of youths feasting and singing

Wir haben am
25 September 1978
geheiratet

We were married
on September 25,
1978

Unsere neue Adresse ist
267 Clarendon Street,
Boston, Massachusetts
02116 U.S.A.

Our new address is
267 Clarendon Street
Boston, Massachusetts
02116 U.S.A.

Jeanne Phelan
Wolfgang Floitgraf

Andrea and Hank
would like to share
the joy of their marriage with you
Saturday the fourteenth of September
Nineteen-hundred & seventy four
at two o'clock
First Baptist Church of Newton
Newton Center, Massachusetts

The William M. Breed family invites you
to continue the marriage celebration by
attending the reception at the bride's home

Please Reply
19 Nebo Street
Medfield
Massachusetts 02052

Come and share our Joy
as we celebrate the marriage of
our daughter

Sarah Elizabeth Menefee
to
Peter Du Val Moore

on July twelfth
nineteen hundred sixty-nine
at three-thirty Nuptial Mass

All Saints Catholic Church
3847 Northeast Glisan
Portland, Oregon

Mr. and Mrs. Towner Menefee

two

become one

in Christ

Cathie Dobson and Jake Wheeler
would like you to join family and friends
for their wedding
Saturday the second of June at three o'clock
Milton Academy Chapel
Milton, Massachusetts

and for a reception
at the home of her parents

R.S.V.P.

Mr and Mrs John Gordon Dobson
118 Needham Avenue
Dedham, Massachusetts 02026

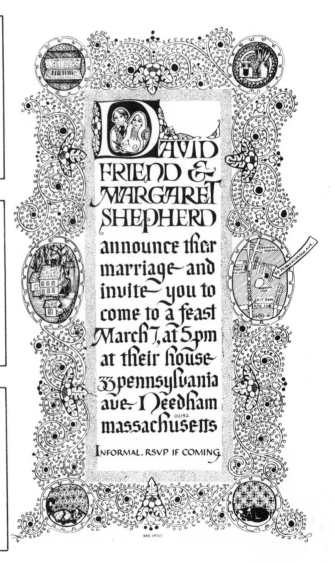

DAVID FRIEND & MARGARET SHEPHERD
announce their marriage and
invite you to
come to a feast
March 7, at 5pm
at their house
33 pennsylvania
ave. Needham
massachusetts
02192

INFORMAL. RSVP IF COMING

MS 1970

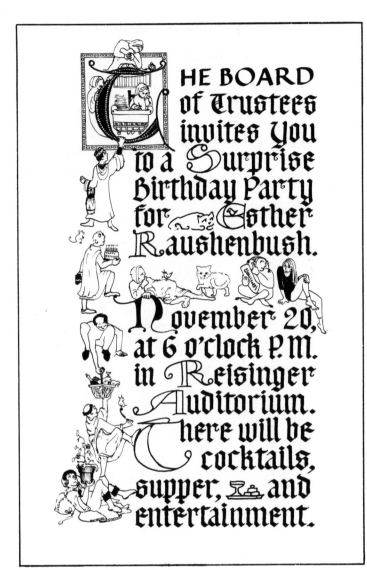

THE BOARD
of Trustees
invites you
to a Surprise
Birthday Party
for Esther
Raushenbush.

November 20,
at 6 o'clock P.M.
in Reisinger
Auditorium.
There will be
cocktails,
supper, and
entertainment.

Sarah Lawrence College
Bronxville, New York 10708

Mrs. Anne Hobler
Sarah Lawrence College
Bronxville
New York 10708

Mr. and Mrs.

ACCEPT ☐
REGRET ☐

The invitation
to a Surprise
Birthday Party
for Esther
Raushenbush
November 20.

Season's
Greetings
& Happy
New Year
from
ARP

Join us for
Christmas
Cheer
4:30 ~ 8:00 p.m.
December 20
ARP Instruments

THERE WAS YNOWH
OF JOIE AND FESTE,
FOREVERE AMONG
THEI LAGHE AND PLEI,
AND PUTTEN CARE
OUT OF THE WEIE.

John Gower

Mark Peterson
and
Indira Shetterly

announce their marriage
and invite you to an Open House
September 8, 5–7:30 P.M.

at their house
211 South Pleasant Street
Amherst, Massachusetts 01002

Please join us
at our wedding
Saturday, August 11, 1979
at 11:30 A.M.
53 Hubbard Street
Concord, Massachusetts

Indira Shetterly
and
Mark Peterson

DIAMOND LIL
is a
Gem

A
celebration
in honor of
her spirit ~ 75 in '76
at twelve noon, Sunday, Aug. 18
514 Worcester Street
Wellesley Hills
R.S.V.P.

David
& Susan

Lois
& Irving

237-2928

Ms. Shepherd
33 Penn. Ave.
Needham
Mass. 02192

WEEK BY WEEK COUNTDOWN
8. Choose date, theme
7. Rough draft & paper
6. Finished artwork to printer; addressing
5. Stuff & mail
4. Invitations arrive
3. RSVPs come back
2. Place cards & chart
1. Party

This is a good time to draw up a SCHEDULE. Working backward from the party date, allow time for all the preparations in sequence. Be just a little pessimistic so that you don't get too many nasty surprises. Make sure all the people involved in party preparations see the schedule and know what's expected of them.

Now, at last, you can execute your black-and-white ARTWORK*. Don't make it too much larger than its intended final size; this just makes it hard to match the invitation to the handlettered envelope. Have the artwork checked by someone else for names, dates, spelling, and size. Take it to the printer, with the checklist shown on page 96.

PLEASE JOIN US
FOR OUR SON'S
CONFIRMATION.

DATE, TIME, PLACE

Mr. & Mrs. Joe Smith
836 Main Street
Los Angeles
California 90201

You are cordially
invited to a
Buffet Party

Date, Time
Location

Mr. & Mrs. Joe Smith
836 Main Street
Los Angeles
California 90201

Two styles of "matching" envelopes for calligraphic invitations. (Note straight and indented layouts.)

While the invitations are printing, work on the envelopes, hand-addressing them in the same style and color as the invitation — or in a harmonizing style if your invitation calligraphy is too time-consuming. Use waterproof ink if you can, or spray each one lightly with fixative to prevent

*See chapter on Artwork for Reproduction, page 91.

smearing. Make a guideline sheet and slip it inside each envelope, using a light table if the envelope lining makes the envelope opaque. Start ahead of time, also, to find the commemorative picture stamp that adds just the right decorative note.

After the invitations come back printed, stuff and mail them. Relax and check off the RSVP's as they come in.

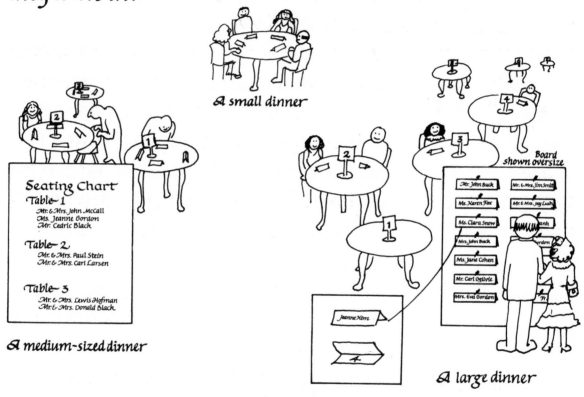

A small dinner

A medium-sized dinner

Seating Chart
Table 1
 Mr. & Mrs. John McCall
 Ms. Jeanne Gordon
 Mr. Cedric Black

Table 2
 Mr. & Mrs. Paul Stein
 Mr. & Mrs. Carl Larsen

Table 3
 Mr. & Mrs. Lewis Hofman
 Mr. & Mrs. Donald Black

A large dinner

Place cards and seating chart for three different sizes of sit-down dinner party

A few days before the party — not too far ahead or you'll just find yourself redoing it — assemble your list of acceptances and make a small seating chart for your own use. For a small dinner or buffet, make place cards and put them by the places. For a medium-sized party with

several separate tables, put the place cards on the table; number the tables, however, and display a seating chart to help people find their seats without wandering about. For a large party, put only numbers on the tables. Add the table number inside the place card and fasten each one to a display board near the entrance. People arrange themselves around their assigned tables. Carry your color scheme, letter style, and party theme throughout the place cards and display chart.

Thank-you note

Monogrammed note card

Photograph

Print extras with invitations

Some parties benefit from a few specialized extras, which can add depth and memorability to your event if they are thought of ahead of time and integrated into the party planning. Thank-you notes and monogrammed note paper can be printed at very reasonable cost if you run them at the same time as your invitations. Consider also designing and printing a small memento for the guests—a photograph of the bride and groom for a wedding, a scripture verse for a bar mitzvah or confirmation, a family tree for an anniversary or gathering of the clan.

Try also to include a memento for the guest of honor. One of the nicest ways to capture the spirit of the occasion is to prepare something for everyone to sign.

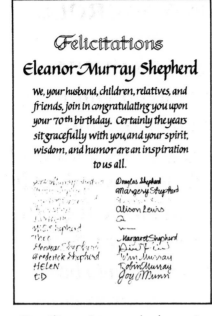

A calligraphic broadside can be framed and displayed.

Three ways to collect guests' signatures at a party

A photo album with a calligraphic title page can preserve and display party photographs, signatures, letters, and telegrams.

A guest book with a calligraphic title page and page headings adds an extra dimension to a wedding or a housewarming.

Three different signature collectors adapt themselves readily to the calligrapher's art: a large decorated proclamation to be framed, a photo album with extra signature pages, and a guest book with handlettered headings. Draw light pencil guide lines, set the document on a sturdy table, and provide a spectrum of colored pens for decorative signatures. Long after the party is over your guest of honor will have a written record of the gathering, in everybody's very best personal calligraphy.

FILLING IN A DIPLOMA, DESIGNING A SCROLL

Much of a calligrapher's work involves giving someone recognition. Diplomas, retirement citations, official proclamations, and honorary degrees all evolve from one source — the near-universal human belief in the printed word. In contemporary society, the handlettered scroll with its echoes of medieval craftsmanship, ecclesiastical glory, and feudal power, carries a special air of authority. Because these documents of recognition are so likely to be preserved and displayed by the recipient, they deserve meticulous care in their execution.

Awards fall into two categories: DIPLOMAS where the name and perhaps date and course are filled in on a preprinted form, and one-of-a-kind SCROLLS individually designed for one person.

If a printed diploma is needed, and if no preprinted form exists already custom-made or

Mass-produced diploma Custom-made diploma Calligrapher-designed diploma
All these samples are filled in with the same calligraphy.

mass-produced, you will need to design one. Start by working out the exact wording. At the same time, set

the general tone for the piece, as form and content should harmonize. Old-fashioned formal wording, full of 𝔚𝔥𝔢𝔯𝔢𝔞𝔰 and 𝔑𝔬𝔴 𝔗𝔥𝔢𝔯𝔢𝔣𝔬𝔯𝔢, benefits from a formally centered layout and an occasional Gothic line, while a

less official "thank you" text can be expressed in an a-symmetrical layout and simple Italic or Bookhand. Some sample diploma designs are shown here to give you ideas on wording and layout.

 Letter the whole diploma artwork

including a sample name, exactly as it will look later. This way, you can be sure the style you intend to letter the name in with will fit the space. (Just be sure to white out the name before the artwork goes to be printed.) Weigh the choices involved and decide whether it makes more sense to put the date onto the artwork or to letter it in onto each one by hand. Now take the artwork to the printer and be sure these two requests are among your specifications: GOOD QUALITY PAPER (try lettering on a sample sheet to test the surface) and MORE COPIES than you think you are going to need (those few extras cost very little compared with the cost of reprinting the job).

When the printed diplomas are ready, carefully lay out guidelines and centering measurements, and letter a sample alphabet along one edge, noting pen size and ink. Lay this next to a diploma as a measuring guide and rule in pencil guidelines, or, if you have a light table, lay the blank over the guideline sheet.

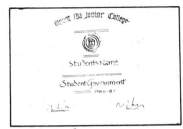

Rough draft

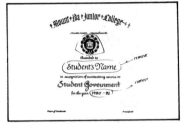

Artwork

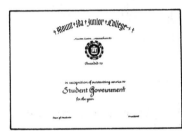

Printed blank

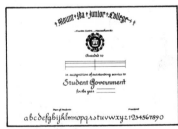

Guideline sheet

Finished diploma

Five stages of designing and producing a diploma

Letter the name. Now you have a guideline sheet and a sample; you are ready to fill in the list of names. Save the sample and guideline sheet along with any extra blanks.

Try to letter the whole batch of diplomas on one day if you can, to avoid subtle changes in letter style. Be prepared to make some mistakes; names are harder to letter than sentences, and demand more concentration.

Once in a while you will be called on to design and execute a one-of-a-kind presentation to an important person on an important occasion. For this project you need a cross between a conventional diploma and a creative piece of calligraphy. Before you even start a pencil layout, get as much information as possible: a typewritten text, number of expected signatures, size and style of frame, general color range, date needed, and anything about the giver or receiver that would help make the design personal, evocative, and unique.

HEADING gives the full name of institution or group conferring award.

NAME of recipient includes titles, academic degrees, and military rank if appropriate.

AWARD name is emphasized. but less than the name of the recipient.

DATE and PLACE are very important. Spell out all numerals. For extra formality, add to the Anno Domini year the institution's year (see first example on page 122).

The many aspects of a scroll

TEXT should read as whole sentences. Avoid contractions and informal wording.

BORDER enhances the award's importance.

SIGNATURES need ample room and, particularly in the case of scribblers, tiny calligraphy underneath giving name and title.

SEAL can include gold decal and ribbons, limit itself to blind-embossing directly onto paper, or be drawn on.

Now pull all these elements together with a pencilled layout. You may want to have the donor check your proposal at this point to make any last-minute changes and to give you the official go-ahead.

Execute the scroll with your finest tools and materials. Use handmade heavy paper or parchment and India ink. You will probably find the formal nature of an honorary presentation calls for a decorative border. Draw and ink the border AFTER the calligraphy is done.

LEFT: Border configurations BELOW: Border styles

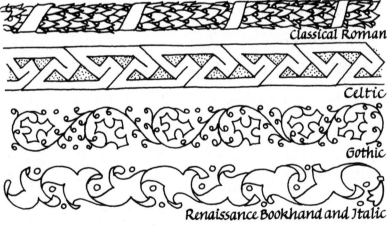

Classical Roman

Celtic

Gothic

Renaissance Bookhand and Italic

Some general border configurations are shown at left. The specific style is up to you. Gather ideas by copying historical examples, studying other calligraphers' work, and experimenting with pen and eye.

Resolution
of
BOARD OF DIRECTORS
of
EMPLOYERS MUTUAL CASUALTY COMPANY
Whereas,
Frederick W. Weitz

son of the late Rudolph W. Weitz, a valued director of this company for over thirty-two years, is presently President of the Weitz Company, Inc., one of Des Moines oldest and most respected building contracting concerns, which has been a continuous substantial policyholder of the Company since its earliest days and was the general contractor for the erection in 1955 of this Company's then new home office, and in 1971 of its present new home office, and Whereas, Frederick W. Weitz served as a member of the Board of Directors of Union Mutual Insurance Company of Providence from 1974 to early 1978 and of the Boards of Employers Modern Life Company from June 6, 1974, and of this Company and Emasco Insurance Company from March 8, 1978, and Whereas, by reason of possible conflict of interest with another of his business affiliations, Frederick W. Weitz felt compelled to, and did, as of September 19, 1978, resign from this Board and those of Employers Modern Life Company, and Emasco Insurance Company, which resignations were accepted with regret, Whereas, his capabilities and sound business judgment were greatly appreciated and valued by his co-directors and were of substantial benefit to such Companies.

Now, therefore, be it Resolved,
that this Board formally records its deep sense of appreciation for the real contributions made by Mr. Weitz, as a director of this Company and said affiliates and its hope for the continuance of the long-time close and warm association between Employers Mutual Companies and Mr. Weitz and the Weitz Company Inc.

Dated at Des Moines, Iowa,
December 1, 1978

Margaret Mead

Twelve years have passed since Lesley College was last honored by your presence. We then had the pleasure of bestowing upon you, one of the world's remarkable women, the degree of Doctor of Humane Letters.
Today, we happily and warmly welcome you as our Commencement Speaker. It is you who will bestow upon us a degree of your wisdom about the arts in contemporary American society, as you speak.
Through your life's work in anthropology and the study of contemporary cultures, as well as the fact that you are the sister of our beloved Liza Stieg, you are uniquely qualified to speak to us. We stand in grateful appreciation of the penetrating wisdom you have already shared with us. We thank you for being here with us today.

GIVEN IN CAMBRIDGE, MASSACHUSETTS, Chairman of the Board of Directors
ON THE TWENTY-THIRD DAY OF MAY,
IN THE TWENTY-SIXTH YEAR OF LESLEY COLLEGE.
ANNO DOMINI NINETEEN HUNDRED President
AND SEVENTY-FIVE

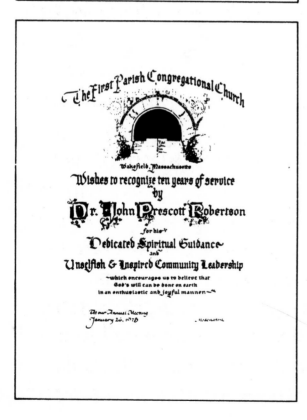

The First Parish Congregational Church

Wakefield, Massachusetts
Wishes to recognize ten years of service
by
Dr. John Prescott Robertson
for his
Dedicated Spiritual Guidance
and
Unselfish & Inspired Community Leadership
~which encourages us to believe that
God's will can be done on earth
in an enthusiastic and joyful manner~

At our Annual Meeting
January 20, 1978

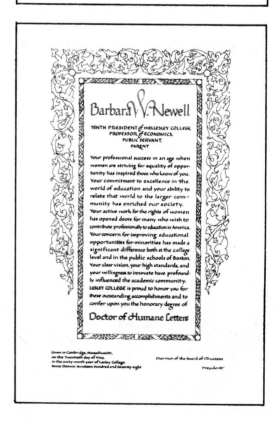

Barbara W. Newell

TENTH PRESIDENT of WELLESLEY COLLEGE.
PROFESSOR of ECONOMICS.
PUBLIC SERVANT.
PARENT

Your professional success in an age when women are striving for equality of opportunity has inspired those who know of you. Your commitment to excellence in the world of education and your ability to relate that world to the larger community has enriched our society. Your active work for the rights of women has opened doors for many who wish to contribute professionally to education in America. Your concern for improving educational opportunities for minorities has made a significant difference both at the college level and in the public schools of Boston. Your clear vision, your high standards, and your willingness to innovate have profoundly influenced the academic community. LESLEY COLLEGE is proud to honor you for these outstanding accomplishments and to confer upon you the honorary degree of

Doctor of Humane Letters

Given in Cambridge, Massachusetts, Chairman of the Board of Trustees
on the Twentieth day of May,
in the sixty-ninth year of Lesley College.
Anno Domini Nineteen Hundred and Seventy-eight
 President

MAKING A LARGE POSTER OR STANDUP SIGN

Into every calligrapher's life comes the need for BIG LETTERS, written not with the traditional scribe's precision and elegance, but with an eye to fast execution, easy readability, and forceful design. These projects usually take the form of posters for walls or standup signs for displays, and demand of the calligrapher a fresh approach to his art. Not only will you change the scale of your letters, but you will use different materials and arm muscles as well.

As you approach big letters, it is helpful to think back 2000 years to the Roman capitals, whose forms actually grew out of the techniques of wall writing. You are turning the clock back, applying the handwritten letter to its original purpose.

a

Working large has another enjoyable side benefit; you can SEE what you are doing. A three-inch <u>A</u> can show you details you never noticed before. You return to your 3/8 inch letters with your arm limbered, your eye refreshed, your mind sharpened, and your under-standing deepened.

Start your poster with typed or neatly written information, a small pencil sketch, and a firm but realistic dead-line. Choose paper or poster material

Doing large letters is like looking through a telescope or a microscope.

according to the display requirements for stiffness and dura-
bility (and the budget requirements). Choose a pen accord-
ing to your abilities and the kind of ink demanded by the
display conditions. Be sure to test ink on paper surface;
nothing is more of a let-down than laboriously drawing
pencil guidelines for
six posters and then
discovering with the
first letter that the
ink makes a blot.

Blotted letter

Smooth letter

Now you are ready to start. Draw guide-
lines for all the posters in one batch. Pencil the words on one
and ink it in to see how everything fits. Using this as your
model, pencil the others and letter them assembly-line fashion.

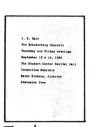

Typed copy

Poster materials include Bristol
board, mat board, poster board,
"railroad board."

Sketch

Model poster

Batch of posters

It's almost amazing sometimes how much better you get as you
do the last few — refining your letters and spacing, and im-
proving the design. Just don't improve it too much; good
advertisement depends on repetition for its effect and that
impact is strengthened to the degree that each poster looks

just like the others. Use your accumulating expertise to do the posters faster and more neatly, not to change the design.

Resist also the temptation to put too much into your design. A poster should grab your attention with one graphic idea and then convey its information as simply as possible while it has your attention. The subtlety and depth of a piece of fine calligraphy are wasted on a poster.

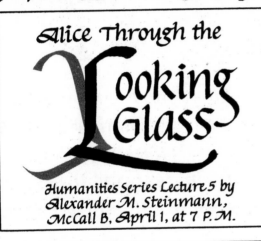

Alice Through the **Looking Glass**

Humanities Series Lecture 5 by Alexander M. Steinmann, McCall B, April 1, at 7 P.M.

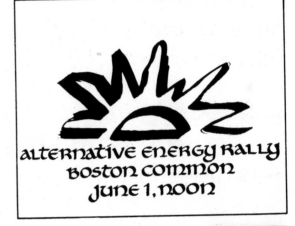

Alternative Energy Rally Boston Common June 1, Noon

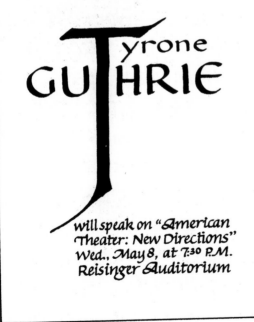

Tyrone GUTHRIE

will speak on "American Theater: New Directions" Wed., May 8, at 7:30 P.M. Reisinger Auditorium

Hear ye, hear ye.

Come find out why The Washingtons Belong in Boston. Faneuil Hall, 3:15 p.m. The speakers are

General James M. Gavin
Mayor Kevin H. White
Lt. Gov. Thomas P. O'Neill, III
Senator Edward M. Kennedy

THE WASHINGTONS BELONG IN BOSTON.

200 Berkeley St., Boston, Massachusetts 02116 (617) 421-4563 (617) 421-4564

If you find yourself lettering more than a dozen posters, look into the economics of reproducing them by silkscreen process from your handlettered original. If you have over 50 posters, and particularly if the event will also necessitate mailing flyers, program covers, and tickets, investigate the cost of having all these items printed up photo-offset at the same time, using different

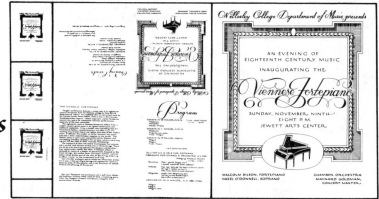

Economize by printing posters, tickets, and programs all at once.

reductions of your original artwork. That way your event achieves a unified look, you get more for your printing dollar, you avoid unnecessary calligraphic toil, and everyone at the event has a beautiful souvenir.

With finished posters — two or 200 — you are ready to put them up. Wall posters can be affixed with double-sided tape, small loops of masking tape, special poster-hanging putty, cellophane tape (on glass), staples, tacks, or pushpins. If PUTTING them up means STANDING them up, as at a crafts fair, convention, or panel discussion, you will need a slightly different approach to materials and design. Use the lightest weight stiff board available (Fom-Kor or smoothly painted corrugated cardboard). Keep the information to a bare minimum; think of your sign as a picture caption for what you want your viewers to focus on.

Folds flat like a portfolio for carrying and storing.

Attach ribbon tie for handling.

Enlarged detail of hinge in foam-core material.

Reinforce with clear tape if sign is used frequently.

If your sign will be set on a table below waist height, put most of the important information above the sign's middle.
The finished sign needs something that holds it upright on a horizontal surface but folds flat to carry or store the sign. A vertical folding-screen arrangement, shown above, holds itself up and carries easily. Remove a strip of front surface and filler twice as wide as the thickness of the sign: leave back surface intact as a hinge.

If cards are hard to fold smoothly, score with back of scissors blade, letter opener or other blunt edge before folding.

If you have a lot of cards to letter, and either no light table or a very heavy card stock, make pencil guidelines with a template.

Another rigid folded sign called a "tent card," used mainly as a place card or a name card at seminars, can be made from material no heavier than an index card.

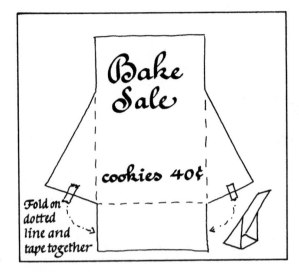

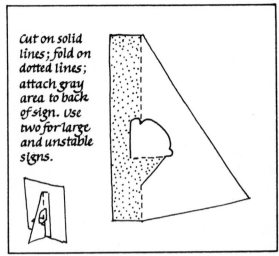

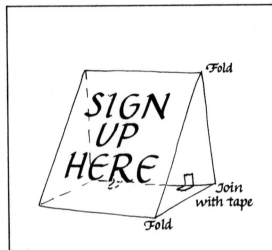

Four ways of holding up a sign

To hold a flat sign securely upright, lean-ing a little backward for best visibility, make a stand out of a simple horizontal fold, the edges of the sign itself, an at-tached cardboard easel back, or a real easel. Some patterns for handmade easel improvisations are given here, in case you can not find the prefabricated item at your local art, craft, or stationery store. For extra stability, set or tape a weight on the bottom of your sign.

IV

Going into Business for Yourself

Business is more agreeable than pleasure; it interests the whole mind, the aggregate nature of man, more continuously and more deeply. But it does not look as if it did.

Walter Bagehot

There is no better ballast for keeping the mind steady on its keel, and saving it from all risk of crankiness, than business.

James Russell Lowell

ow you have all the technical, artistic, and practical knowledge you need to go into business. You may be ready to look for work, or the work may already have started to find you. You may be hoping for steady, full-time work, or you may be happy with an occasional job. In any case, as an advancing calligrapher starting in business you share two big problems with any other self-employed person: how to get requests for work and what to charge for it. Solve these two questions and your other problems will be small ones.

Before you can get answers, you must phrase the questions right. What do you want to get out of your calligraphy business? Make a list, if necessary, with three headings: your abilities as a calligrapher, your financial needs and resources, and the opportunities open in your local community. Be realistic, even a little pessimistic. Can you really call teaching at a nearby museum school an opportunity if you're a beginner? Will you be happy addressing envelopes for a living if you're a master craftsman? How many calligraphers are there already in your area? Will this work for or against you? If your local area doesn't fit your abilities, are you prepared either to sacrifice some of your income requirements or go outside your community (i.e. mail-order or commuting to teach)? Be forewarned, however,

that most freelancing is best done locally. Try to find a way of balancing the three realities on your list.

The next set of questions concerns whom you should try to reach as a possible user of your calligraphy. Think about the projects you know how to do; ask yourself how they fit into the needs of the outside world. A favorite quote can sell to almost anyone. The more expensive and unconventional it is, the smaller its segment of the general public. You can make this work to your advantage by choosing quotations with a specific professional, religious, ethnic, geographic, or age group in mind. Logos and letterheads are needed by small companies, individuals, and advertising agencies. Printed brochures and posters are needed by just about anybody selling a product or organizing an event. Party and wedding invitations and seating can be done either for the general public or for the party shops, bridal services, and caterers they patronize. Diplomas are awarded not only by schools but also by corporate training programs, while citations are awarded by nearly every civic, ethnic, public, governmental, and veteran's organization. And a calligraphic family tree can grace the home of a pedigreed dog as well as a pedigreed human.

Now hold a brainstorming session. How are you going to reach these people? How can they reach you? Picture the kinds of information that come into their lives: will you reach them best with a newspaper advertisement? a telephone call? a mailer? There are

usually several likely ways to reach someone; choose the most economical, so that you can contact more people and increase your chances of getting a response.

A few guidelines may help. <u>First</u>, have confidence in yourself and in your work. It isn't that your work isn't good enough to be noticed; it's that the people who need your services don't know you exist. Your confidence will help you get your calligraphy to the outside world. Spend some time arranging your best work in your portfolio, to show your talents to their best advantage. <u>Second</u>, to catch a duck, think like a duck. Picture yourself in the place of the person whom you are trying to reach, the person who needs calligraphy but doesn't know where to go for it. The first reaction of many business people when they can not find a service is to pick up the telephone and call someone else for advice. Small business owners call their local printer, corporate executives call their advertising agency, advertising agencies call their typesetter, people with a favorite quote call their local Y or adult education center, boards of directors ask their law firm's purchasing agent. So if you can't reach or afford to reach your potential clients, reach the person they are most likely to call for a word-of-mouth recommendation. <u>Third</u>, be persistent. Not pushy; persistent. Many people may need you every two years. Others move away, change jobs, are promoted, or lose your card. You have to keep letting them know you're there, year after year.

There are at least ten good ways for you to promote awareness of your services. Try the one, or combination of several, that suits your temperament and talents, and seems likely to reach those people whom you want to call you for calligraphy:

1. Send press releases to all the local media, including a factual account of some interesting aspect of your calligraphy, a printed sample, and an 8" by 10" glossy photograph. Sometimes one good human-interest write-up or interview can establish you in your community.

2. Have a mailer printed up and mail it to every corporation, law office, government agency, library, hospital, church, school, party store, advertising agency, and publisher in your area. Wait six months, smile sweetly as you clench your teeth, and send a new mailer to the same list. Wait another six months, keep smiling, and send yet another mailer. Repetition is essential.

3. Telephoning is weak for transmitting the visual importance of calligraphy. Use it in conjunction with other techniques — to follow up mailers or arrange sales calls.

4. Put up a calligraphy exhibit in your local bank, church, or library. You'll reach people in a surprising range of occupations who will remember you for the next calligraphy job.

5. Take your work to show at a convention or to sell at a crafts fair. Talk to people to find out what they like. Watch their response to different prices, different designs. You will get valuable feedback, sell a few things, give your card to hordes of mildly interested people, and occasionally make a useful connection.

6. Advertising can be risky for the freelancer—unless you are expert, you may end up spending the money without getting the results. As with mailings, target your audience and aim for repetition. Four lines in the classifieds every week may be more productive in the long run than one quarter-page twice a year.

7. Sales calls, where you show your portfolio to a prospective client, usually follow an initial contact. The exception is "cold calls," where you simply

walk in off the street and ask to see the
buyer or purchasing agent. This is a high-
risk, high-gain technique, not for the
faint-hearted; it may hopelessly alienate
the schedule-conscious executive, or
prove to be the only way to reach a busy
retail store manager.

 8. Sometimes just put-
ing your card or brochure on the right
bulletin boards can generate demand.

 9. Give some thought
to asking established calligraphers to
pass extra work along to you.* Making
this request takes courage and an iron-
clad confidence in your portfolio. What's
in it for them? Benevolence, lightening
their peak work load, or an interest in
receiving the 10% – 20% referral fee
customary in such arrangements.

 10. If you already have
connections in the sphere of business of
your potential clients, if your calligraphy
is of professional caliber, if you have inde-
pendent wealth, then maybe word-of-
mouth will do your publicity for you
over the next five or ten years. Maybe.

* Don't be surprised if they send you their dullest, least profitable jobs. Wouldn't you?

After your efforts start producing requests for your work, you must face the other major problem of the beginning freelancer: how much to charge. The very best answer to this question is the most obvious—charge what everyone else charges. Call other calligraphers and ask them their rates.* Don't charge more than these rates because it takes you longer; spend whatever time is needed to make the job LOOK RIGHT. This is vitally important, as your work represents you to the outside world of other potential clients. Don't charge less than these rates because your work isn't as good; you only drag down the whole field's standards of quality and make it harder for professional calligraphers to charge decent rates. If you can't do a job at the going rates, then pass it on to those nice calligraphers who gave you prices on the telephone, and go back to the drawing board for more practice.

Sometimes, however, it is genuinely difficult to estimate a price. It's like asking how much lunch costs—it depends upon the lunch. Ask for more information. Try to foresee problems. Hedge by giving a price range, explaining that to some extent you can put in less or more labor without affecting the quality of the design. Or ask, "How much did you want to spend?" and take it from there. Some people, especially businessmen with budgets, will appreciate your openness.

* You may want to pose as a client. Some calligraphers are unduly secretive about prices and touchy about competitors. And they all <u>hate</u> to have anybody waste their time.

If a job involves a significant expenditure for materials, estimate the calligraphy alone and ask the client to purchase the materials. Or you can buy them and bill the client, adding on 15% for your trouble.

When you have agreed on a price, in some cases received a deposit or a purchase order number, written a brief description, gotten a typed copy of the client's text, submitted a rough draft or two for approval, lettered the job, and doublechecked it for errors, you have one more step to complete. ALWAYS SEND A BILL. Any organized business won't pay without it; you need a record of who owes you what, and even if you're donating your work you want to let people know what it's worth. (Submit an invoice with the words "no charge" added.)

While self-employed calligraphy can make money and save taxes for you, you are not exempt from the necessities of accounting. Keep your bookkeeping procedures to a minimum, and then do them without fail. First, hang onto a receipt, invoice, or cancelled check for every bit of money that goes out or comes in. Second, maintain a log of your projects as you do them. Buy preprinted log books at a stationery store or draw up your own. And

Client	Job Description	Date Begun	Date Done	Total Hours	Invoice #	Amount	Paid?	Check #
N.E. Bank	40 awards @ $2.	2/26	3/10	5	028	$80.00	✓	11312
Mr. Geller	Birthday quote	2/28	3/20	3	029	$25.00		

A typical log book

finally, keep your calligraphy finances separate from your personal finances, with two credit cards and checking accounts if possible.

Starting a business—even a one-person business—can be expensive. You will need to invest a certain amount of money "up front" to cover the expenses of getting work, of buying tools, furniture, and supplies, and of taking extra time on each job. It's better to overestimate this amount by building up extra savings or working another part- or full-time job until your calligraphy business starts making money, than it is to underestimate and have to abandon your business just as it picks up speed.

As you take on more work, your talent for lettering will gradually grow from a hobby to an occupation, with all the demands for time, space, and attention of any thriving young business. The suggestions given here can help you get it launched, keep it afloat the first year, and guide it in the direction you want it to go—so that you can reach your full potential as a calligrapher.

THIS BOOK WAS HANDWRITTEN BY THE AUTHOR,
on Strathmore Calligraphy Document paper, one and
one-third times larger than final size, in Italic
lettering, using India ink, with a #3 ½
Mitchell nib, on a 4 mm letter body
with 6 mm spaces between lines.
Swashes are incorporated
into the capitals and into
y, j, and f, to make
a graceful yet
clear let-
ter

.